LEGEND

OF

SCITUATE

MASSACHUSETTS

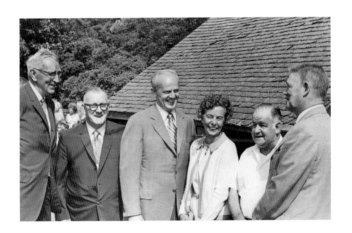

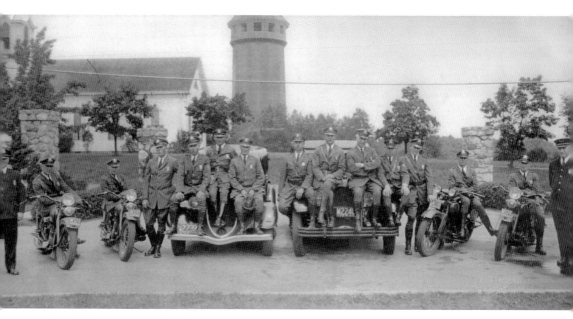

The 1935 Scituate Police Department
Chief Michael Stewart and future chief Bill Kane flank the 1935 Scituate Police Department with the Lawson Tower as a backdrop. (Scituate Historical Society.)

Page 1: Business, History, and Politics Meet at the Stockbridge Mill in 1966
A slice of life in Scituate is captured in this image. Major players are here from all the different spheres of influence. Some had their greatest work behind them; others would go on to make an even bigger mark. (Scituate Historical Society.)

LEGENDARY LOCALS

— OF —

SCITUATE

MASSACHUSETTS

MAT BROWN, BOB GALLAGHER, AND CAROL MILES

Legendary Locals is an imprint of Arcadia Publishing
Charleston, South Carolina

Printed in the United States of America

Library of Congress Control Number: 2012954912

For all general information, please contact Arcadia Publishing:
Telephone 843-853-2070
Fax 843-853-0044
E-mail sales@arcadiapublishing.com
For customer service and orders:
Toll-Free 1-888-313-2665

Visit us on the Internet at www.arcadiapublishing.com

Dedication
This book is dedicated to the townspeople of Scituate, for their insistence, in every generation, that the past has lessons that inform a better future.

On the Front Cover: Clockwise from lower left:
Farmer and school aide Esther Prouty (courtesy of Carol Miles, see pages 101–102); farmer Alfred Gomes (courtesy of Connie Gomes, see page 112); photographer Rudolph Mitchell (courtesy of the *Scituate Mariner*, see page 117); businessman and philanthropist Jack Conway (courtesy of the Scituate Historical Society, see page 60); entrepreneur Lucien Rouseau (courtesy of Joan Noble, see page 67).

On the Back Cover: From left to right:
The Patterson family (courtesy of Tucker Patterson, see page 56); actor Bates Wilder (courtesy of Bates Wilder, see page 75).

CONTENTS

ACKNOWLEDGMENTS

The trustees and officers of the Scituate Historical Society encouraged and sustained this project from the start and they have our thanks. Nancy White of the *Scituate Mariner* was generous with her time, and the work of various *Mariner* photographers honors this project. David Corbin is a constant resource for anyone who wants to expand his or her knowledge of local history. Town of Scituate Archivist Betty Foster brings a love for the town and for its history to each and every person who makes their way down the stairs to the basement of town hall. Our families should be noted for their sacrifice of time and patience. We cannot fully express our gratitude to all the families of Scituate who responded to our call for photographs and stories. They are legendary in their graciousness.

INTRODUCTION

For more than 375 years, Scituate, Massachusetts, has been a home to individuals and families that have offered examples to the nation. For good and for bad, Scituate has been home to newsmakers, educators, entertainers, politicians, and athletes who have taken their gifts out into the world to some acclaim.

Scituate has also been home to individuals and families who have chosen to make the town their focus. In small businesses, in public schools, in local political life, and in medical practice, there has been, in virtually every generation, a stalwart band who offered their skills and enthusiasm to the public life of this particular place.

Located equidistant between the two better-known colonial settlements of Boston and Plymouth, Scituate celebrated its 375th birthday in 2011. Very few towns in the United States can claim a longer history and few are prouder of the stories that have been shared across those years. In this book, the reader will get a chance to learn some of those stories through the brief biographies of men and women and families that can be marked as prominent examples of Scituate's donation to the wider community. Readers will also get to learn of those people whose contributions were more intimate but no less valuable. The metaphor of the thrown stone rippling in the pond comes to mind.

This book should by no means be seen as encyclopedic. The desire to entertain as well as educate drives its creation. This twin charge has meant that many worthy choices were set aside for another day as their contributions were mirrored in another choice.

From Timothy Hatherly's establishment of a colony between the North River and the rocks of Cohasset; to James Cudworth, who lost his position to the intolerance and the politics of the Puritan ministry; to Chief Justice William Cushing stewarding the country away from slavery and toward a more complete union, the first phases of Scituate's life stand as examples of how, in America, there was an evolution of political ideas about an individual's place in a community.

Scituate, it will be seen, was a town well known for its tolerance of differences and its ability to assimilate the immigrant without violence or bigotry. Despite a modern understanding of the town as "the Irish Riviera," Scituate has had a diversity, and a harmony among its disparate groups, that can be seen as a model for the wider understanding of the United States as a "melting pot."

When, in the 1800s, carrageenan or Irish moss was found off the coast of Scituate, there was a transition from Yankee to immigrant and the census records of the time show one group living and working beside the other from the harbor to the West End. Daniel Ward led this charge of the immigrant and created an industry that influenced the expansion of the American economy. Used as an ingredient in a dizzying number of products, Irish moss is an example of a product that was integral in the competition for markets that marked the second half of the 19th century.

Scituate had always been part of the economic life of the nation because of its shipbuilding. The oak, walnut, and maple that lined the North River and the talents of the chandlers, carpenters, and sail makers had combined to create a flourishing shipbuilding industry just as the United States was being established. The ships *Columbia* and *Essex* belong to that first nationalistic and entrepreneurial impulse. The most famous and enduring symbol of Scituate, the lighthouse at the mouth of the harbor, belongs to that era as well. The shift from an economic life organized around one industry and transitioning to another as technology changed is a story thousands of American towns have repeated across the past two centuries. Once again, Scituate can be seen as a microcosm for an often repeated pattern.

In the 20th century, Scituate was reinvented again from a sleepy South Shore town most of the year to a summer destination. Hotels multiplied from the Humarock neighborhood up to the stunning beach in Minot. There was a social life that included golf, boating, and tennis, and it lived alongside the traditions

of farming, fishing, and lobstering. Scituate built new schools, named new roads, and tore up pasture for subdivisions, all the while welcoming artists, writers, politicians, and yet another generation of immigrants, this time from Dorchester, South Boston, Brighton and other Boston neighborhoods disrupted by court-ordered bussing. There was an influx of immigrants from the Cape Verde Islands as well. New challenges emerged for its political life and new opportunities emerged for its economic life.

The Gates family, the Stewart family, the Pattersons, and the Monteiros are the emblems of this change. Once again, the diversity of the names gives the hint of the lesson. Just as the greater United States has found a place for the talents and the ambitions of countless ethnicities, so has Scituate been made a home by members of all faiths and races. The town has promoted and celebrated the gifts of all its residents and it has done so in the spirit that informed James Cudworth and William Cushing in its early years. If you were talented, driven, inspired, relentless, generous, practical, devoted, inspiring, or just plain smart like the Thinking Machine of Jacques Futrelle, Scituate would notice and support you. In the best example the town could set, prejudice was pushed aside.

Scituate has been the setting for celebrations and tragedies for more than 375 years now. The individuals and families that have lived there can be seen for illustrations of constants and changes in American life more widely. When the nation called them, they went too. More than 1,600 Scituate residents have served in the armed forces, from the Revolution to the wars of the 21st century. Memorials on the town common note those sacrifices. Memorial Day and the Fourth of July are important days in Scituate, another quality shared by countless towns all across the United States.

Scituate, Massachusetts, and its legendary locals tell the story of the country in its doggedness and its flashes of lightning. There is the bedrock of the nation and the fits and starts of growing. From its first generation to the current one, Scituate has had stories to share and lessons to teach.

CHAPTER ONE

Cream of the Crop

Small towns have long memories. Small towns also produce remarkable people. The combination of those people and those memories can read like a fish story sometimes, with each telling getting a little bigger, a little more difficult, a little more than the truth. That is not so with this list.

The Founder, the Explorer, and the Mogul are larger than life and were in life as much as they are in memory. Timothy Hatherly, Col. Charles Wellington Furlong, and Thomas Lawson were giants in their time and it was no secret no matter where you went. They burned brightly, and from time to time we note their efforts, but in many ways their work has slipped away from us.

The contrary could be said of the Judge, the Scientist, and the Artist. Chief Justice William Cushing, Carl-Gustaf Rossby, and Henry Turner Bailey can be seen as specialists. Each had his impact in a smaller circle that rippled outwards until it influenced a much wider one. Their work endures in their studies and their writings. In the modern era, we go back to them for lessons.

The General and the Abolitionist offer us their gifts. The lives of James Cudworth and Charles Turner Torrey resonate through time yet. From General Cudworth we learn of tolerance. From Charles Turner Torrey the message is one of sacrifice and idealism for the most noble of causes.

In the stories of the Doctor and the Teacher, we gain an insight into ambition and dedication and the difference that an individual can make in a small town. Dr. Max Miles and Sally Bailey Brown served Scituate for two full generations and were actors in its development all the while.

The last two inclusions are the Engineer and the Historian. From Edward Coverly Newcomb, we can take a tale of inventiveness in the most inventive of countries. From Kathleen Laidlaw, a dogged insistence that the past tells the most important tales and that to lose sight of that is criminal. Scituate has had other individuals who offered their skills and drive in similar manners.

This is the cream of the crop.

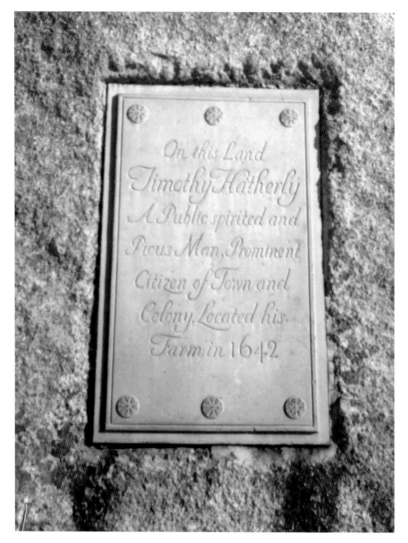

Plaque Marking Hatherly Farm

Two things can be ascertained from all the records left behind of Timothy Hatherly: he had guts and he had brains. Born in 1588 in England, Hatherly set sail for America to find a place to make his mark. Arriving in Plymouth in 1623, he was elected to a number of offices including assistant governor and commissioner from Plymouth to the United Colonies. Broken by a fire that destroyed his house and belongings, he returned to England before moving to Scituate in 1634. There, he joined the Merchant Adventurers of London in the development of the Conihasset Grant. Buying out his early partners, and with settlers already in place inside this grant, Hatherly organized the Conihasset Partnership of 25 men and one woman (Ann Vinal) to resolve any potential dispute while also creating the framework for the town to be developed. Current Scituate family names like Jenkins, Tilden, Merritt, and Stockbridge were part of this group. This partnership combined economic development with political management. One does not think of Scituate as having had plantation life but under Hatherly, it came very close.

Scituate would not turn out to be the merchant opportunity Hatherly believed it to be at the outset. The ground was too rocky and it would be some time before the timber and the iron along the North River was exploited for ship building. Nonetheless, Timothy Hatherly was the founding father of the town and the oldest roads carry the names of him and his partners to the present day. (Bob Gallagher.)

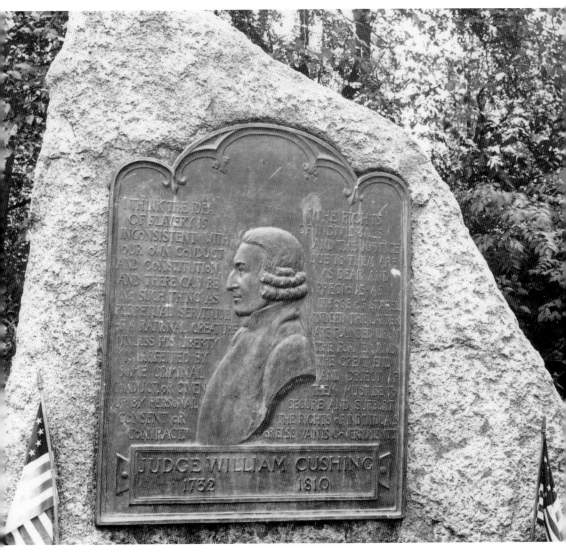

Chief Justice William Cushing

Chief Justice William Cushing is one of the most important and influential figures who ever lived in Scituate. His contribution to the abolishment of slavery in Massachusetts and his role in the ratification of the US Constitution guarantees that. Son of Supreme Judicial Court Justice John Cushing, William served as chief justice for the Supreme Judicial Court of Massachusetts from 1777 to 1789 upon his father's resignation. Called to service on the Federal bench by George Washington, Cushing held that post from 1789 to 1810.

With the resignation of John Jay from the bench, and the reluctance of Congress to ratify the appointment of John Rutledge, President Washington sought to elevate Cushing to the position of chief. Cushing thought it over, considered his health, and expressed his desire to continue as an associate justice.

Among the important decisions and cases in the career of William Cushing, two stand out. He presided over the decision that outlawed slavery in Massachusetts in 1783 when in his charge to a jury he cited the 1780 Massachusetts Constitution and its assertion that "all men are born equal." In *Chisholm v. Georgia*, he found that a citizen of one state could sue another state, a nationalist position that would echo into the modern day civil rights battles. (Scituate Historical Society.)

Col. Charles Wellington Furlong

As unique a figure as the town of Scituate has ever known, Col. C. Wellington Furlong traveled the world as an explorer, spy, naturalist, and writer. Settling in Scituate in the 1920s, he became a voice for the development of the harbor as a commercial center and the creation of the greenbelt along route 3A.

Colonel Furlong first came to prominence as the age of Imperialism was dying out. Said to be the first white man to live among the pygmies and later writing about his exploits in the deserts of North Africa, Furlong was part of the generation that carried the "White Man's Burden." (Scituate Historical Society.)

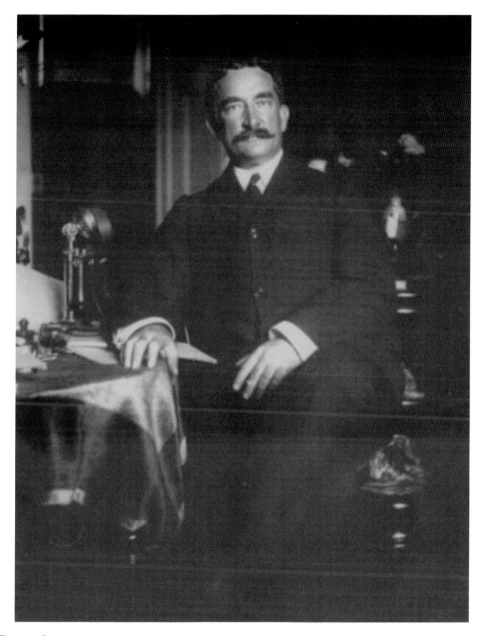

Thomas Lawson
What can be said of someone who began his life in business shoveling gold coins in the basement of a Boston bank, made and lost several fortunes speculating, found time and means to become an enemy of J.P. Morgan and John D. Rockefeller, wrote on topics as diverse as baseball and selling short, and built the epic estate Dreamwold in the heart of quiet Scituate? In a life that mirrors Fielding's Tom Jones, Lawson drank in the life of the best horses, dogs, paintings, sculptures, and all the other accoutrements of the Gilded Age.

When he revealed the secrets to wealth in his book *Frenzied Finance*, he made enemies. When his risks backfired, he had no one to turn to for support. Scituate will remember him though as the citizen who built the dream that changed the town forever. (Scituate Historical Society.)

Dr. Max Duffield Miles

In 1925, a year after Max Miles obtained his medical degree from Case Western Reserve Medical College in Cleveland, Ohio, he and his bride of one month (Margaret, daughter of Henry Turner Bailey) took ship via London, the Suez Canal, and the Indian Ocean to Rangoon, Burma, where, after collecting a mountain of supplies, they set out for Kengtung as medical missionaries. In Kengtung, he and his wife would see their three children born, Matthew, Paul, and Josephine.

After serving his five-year term, the Miles family returned to Margaret's hometown of Scituate, just in time for the oldest child to begin school. Max established a medical practice there that would span more than 40 years. He was the school physician for 30 of those years, often seen moving his camp chair up and down the sidelines at football games. (Carol Miles.)

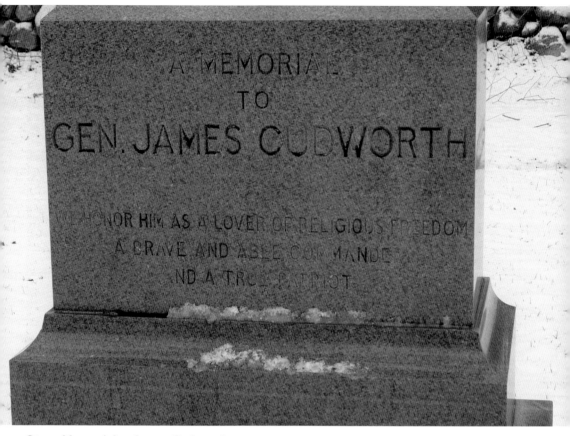

Stone Memorial to James Cudworth
Of the many things of which Scituate is justly proud, few come down through time with as much importance as the public career of James Cudworth. A contemporary of Myles Standish (Cudworth and Timothy Hatherly would be named as executors of the Standish will), James Cudworth stands out as a pioneer in the area of religious tolerance.

Stripped of his various positions due to his finding the Quaker faith to not be a threat to the fledgling Puritan settlement, Cudworth held his ground, writing, "But withal, I told them, That as I was no Quaker, so I will be no Persecutor." He was restored to full citizenship after that response and would go on to be a military leader in King Phillips's war. (Bob Gallagher.)

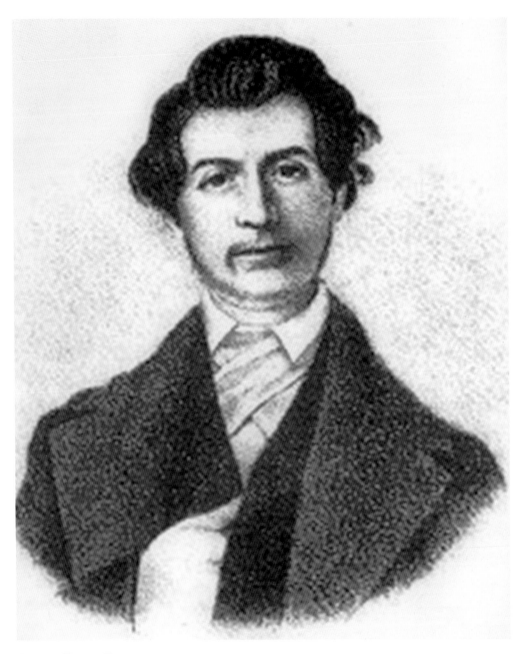

Charles Turner Torrey
In the 1830s, the US House of Representatives began the practice of forbidding the introduction of bills concerning slavery. The "gag rule," as it came to be known, was challenged again and again by Scituate's representative at the time, former president John Quincy Adams. In Scituate, a young preacher named Charles Turner Torrey began his career as an abolitionist. He was among the first to take the stand against the evil that would divide the nation in war. Jailed in Maryland for offering his help to the Underground Railroad, Torrey died in prison. He was later memorialized in poem by 19th-century giant James Lowell. (Scituate Historical Society.)

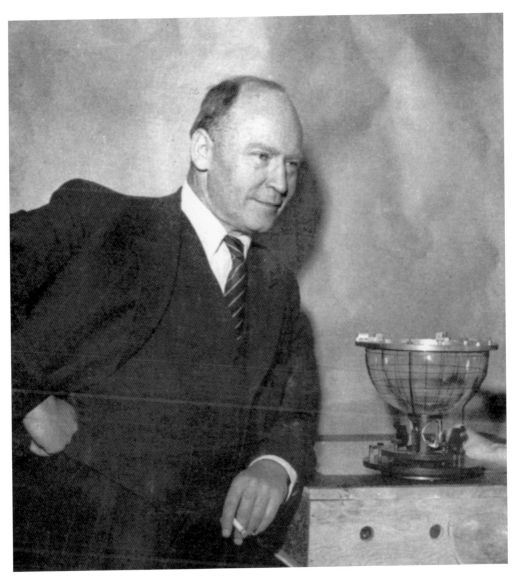

Carl-Gustaf Rossby

In Scituate, the weather is a frequent topic of conversation. In the late 1920s and early 1930s, Scituate was home to Prof. Carl-Gustaf Rossby, one of only two Scituate residents to ever be on the cover of *Time* magazine. (The other was astronaut Edwin "Buzz" Aldrin.) Rossby was the recognized expert of experts in the field of meteorology in the 1950s.

The Carl-Gustaf Rossby Research Medal is the highest award for atmospheric science of the American Meteorological Society. Rossby Waves are a phenomenon he identified and subsequently were named for him. Rossby was first to identify and study the characteristics of the jet stream. His did pioneering work in a field that engrosses us today. While not a household name, Professor Rossby's contributions to the town and to the international community were profound. (Scituate Historical Society.)

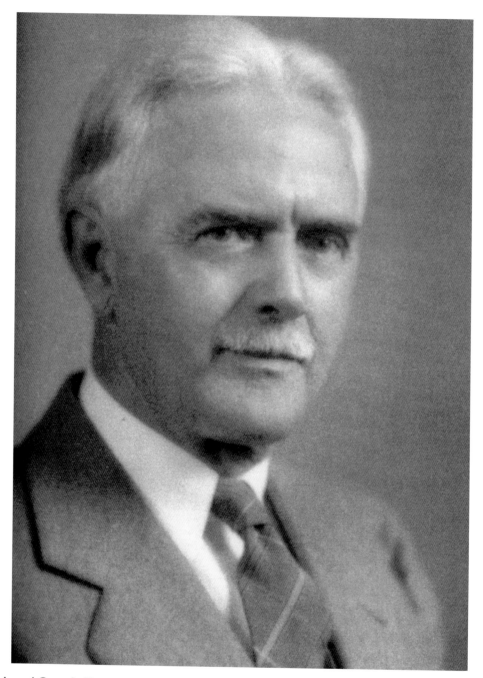

Edward Coverly Newcomb

A prolific inventor, Edward Coverly Newcomb contributed mightily to the early days of the automobile. Studebaker and General Motors were Newcomb clients. In an era of engineers, Newcomb stood out for his mastery of many different types of engines. Electric motors, gasoline, and steam engines fell into his areas of expertise. Diesel engines were a field Charles Newcomb could be said to have pioneered. As the United States changed from rail to road, Edward Coverly Newcomb brought his imagination to the defining industry of the 20th century. (Ed Swift.)

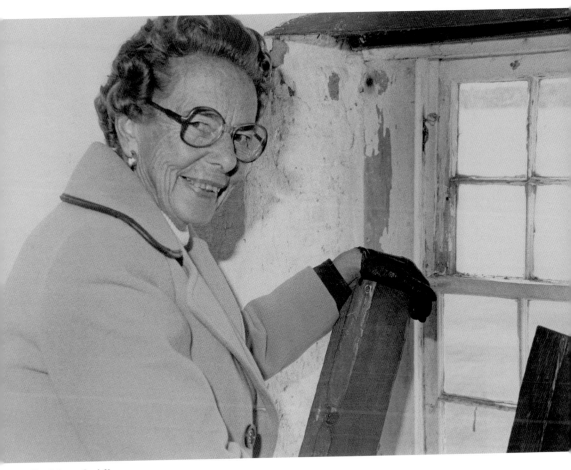

Kathleen Laidlaw

No one who met her ever forgot her. She was a force of nature unto herself. With a drive that was second to none and a mission to preserve the past for the future, Kathleen Laidlaw made her mark and made her mark again as the president of the Scituate Historical Society from 1965 until her passing.

Under her direction, the society became custodian of the Scituate Lighthouse, the Mann House and Barn, the Old Oaken Bucket House, James House, and the Lawson Tower. Every few years, it seemed that another property was in danger from neglect, and she rallied her forces together at town meeting. She lost once in a while, but she hung more victories on the wall than most.

In her monthly newsletters, she revealed her love of the town and of its history. She delighted to see the lighthouse on the cover of a phone book or a story of a project recounted in the *Mirror* or the *Mariner*. Kathleen Laidlaw was one of the secret weapons hiding in plain sight that made Scituate a tourist destination again. The thousands that flock to the Scituate coast and enjoy a taste of the past here owe her a colossal debt. (Scituate Historical Society.)

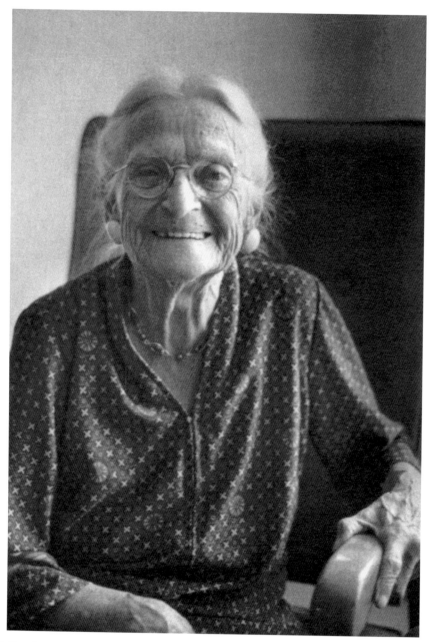

Sally Bailey Brown

A legend in a class by herself, Sally Bailey Brown virtually invented art instruction for young people. At one time responsible for classes in five separate towns, "Aunt Sally" embodied the changing times for women that were the first two decades of the 20th century. Admired for her discipline and her forthright manner, she became the most admired woman in Scituate during her long life. No other woman had a day declared for her as Sally Bailey Brown did in October 1996. A picture of her adorns the lobby that leads to the art wing of Scituate High School today to remind later generations of student artists that they stand on the shoulders of a giant. An annual scholarship is given in her name as well. (Josephine Schuman.)

Henry Turner Bailey

Henry Turner Bailey had it all. His boundless energy, enthusiasm, and intellectual curiosity were contagious. First and foremost, he was an artist and a teacher of art, preeminent in that field. However, that did not stop him from learning all he could about literature, nature, art history, architecture, and photography.

After graduating from Massachusetts Normal Art School, he was appointed in 1887 as the first supervisor of drawing in the state of Massachusetts. He traveled all over the state to present his practical and imaginative ideas on how to teach art to schoolchildren successfully. He founded the *School Arts Magazine* in 1903 and was its editor for 16 years. Meanwhile, the town of Scituate saw him serving in various capacities including that of town moderator (1895–1916). He was a founder of the Hatherly Country Club, the Pierce Memorial Library, and the Scituate Historical Society. In 1902, he designed the town seal, which is still in use today. (Carol Miles.)

Portrait of Himself by the artist From a mirror –

True Son of Scituate

During the summers of 1909–1917, Henry Turner Bailey and his family were in Chautauqua, New York, where he was the director of arts and crafts for the original Chautauqua Institution. From 1917 to 1930, he was the dean of the Cleveland School of Art and also a founder of the John Huntington Polytechnic Institute in the same city. Six times he was the United States delegate to the International Art Congresses: Paris (1900), Berne (1904), London (1908), Dresden (1912), Paris (1926), and Prague (1928). He also wrote many publications and books on art. In 1925, he received an honorary doctor of humane letters from Dennison University, and in 1928, an honorary doctor of art degree from Beloit College.

A true son of Scituate, Henry returned to "Trustworth" (the home he designed) each year to refresh himself with the beauty and tranquility of his hometown. His advice to children was, "Be different; the Lord doesn't want us to be like a row of potatoes." (Carol Miles.)

CHAPTER TWO

Taking Charge and Giving Back

Somebody has to be in charge. Someone has to step up and run things. Scituate has had its share of somebodies willing to throw a hat in the ring and set the policies and guidelines that governed the town. At times, the work was done and the parades noted the success. Other times, the work was done and the result not realized for years. The agendas changed, the times changed, the constituencies changed, the town of Scituate changed. There are many sides to politics and power and Scituate offers examples of all of them.

John Y. Brady was a schoolteacher turned philanthropist. Each summer, he gathered the community together for a carnival. He also chaired the school committee and the zoning committee that shaped the growth of the town.

Dr. Carl Pipes believed in the virtues of the open space. Years from now, hikers will offer their gratitude for the green zone that he supported and expanded. "Sonny" McDonough and James Michael Curley were legends in their field. That field has been defined for good or bad, but few were ever better at it.

Jackson Bailey and Nathaniel Tilden were homegrown leaders dedicated to the town and state with deep conviction. One was a second-generation plumber. The other was a fine gentleman farmer. Jamie Turner was cut from that same cloth.

As women emerged in local politics (Patsy Proctor had been a pioneer on that ground), Evelyn Ferreira, Susan Phippen, and Pauline Guivens sought elected positions and won. They mastered the ins and outs of town hall before moving to other challenges.

Contemporaries Joe Norton and David Ball worked on committees, boards, and societies for a full generation contributing good ideas, organizational skills, foresight, and common sense to the common weal.

William Henry Osbourne began his journey at the fabled lighthouse at the mouth of Scituate harbor. His journey took him into the service of his country and its highest military honor. His was a different kind of taking charge and the greatest form of giving back. The town's greatest monument marks his donation. These are leaders all.

Jackson E. Bailey

Picking up the book *Tell Us a Story, Jack!* reveals Jackson Bailey's puckish sense of humor. A wonderful storyteller, Jackson Bailey loved his hometown of Scituate, and that love shines through every word.

Jack was a Scituate selectman from 1955 to 1964 when it was a three-man board. These men looked after the town's business, from the budget to the everyday challenges of living by the water. Chairman for six of the nine years, Jackson Bailey also served as burial agent for three years and chair of the Jenkins School Building Committee for two.

The Bailey family lived on Country Way next to the Baptist church. Jackson Bailey served on church boards and famously sang in the choir. His beautiful tenor voice carried cantatas and musicals to the rafters. (The Bailey family.)

Dr. Carl Pipes

Dr. Carl Pipes was a self-taught authority on the impacts of development and did his best to steer Scituate in the direction of responsible and environmentally safe decisions. In his eight years on the Scituate Conservation Committee, he was instrumental in the acquisition of more than 200 acres in the West End, and he was also largely responsible for the purchase of the Boston Sand and Gravel property on the Driftway. Through his efforts, a walking trail was established on the Ellis property in North Scituate and walking trails and a playing field were built at Teak Sherman Park. Today, that property is the site of the community garden.

The open space citizens enjoy today—and what makes Scituate such an appealing place to live—can be credited to Dr. Carl Pipes, a man who truly loved the landscape and the backwoods of Scituate. (Penny Pipes.)

John Y. Brady

As school committee chair, zoning board of appeals chair, grand knight for the Knights of Columbus (the pool is named in his memory), or as the father of five, John Y. Brady made plans.

As the organizer of the annual carnival, "John Y." would fill up his car with kids and, later, grandkids, and motor around the South Shore filling store windows with signs. An entrepreneur, he owned Harbor Tire and Bike before moving on to serve as deputy collector for many Massachusetts towns.

A longtime teacher, John Y. brought humor and adventure to everyday things. His son Mark shared a story on the occasion of his father being named citizen of the year. At an auction of office supplies, he watched in horror as John Y. prepared to bid on thousands of paper clips. What would he do with them? What would he do?

He was a man with plans. (The Brady family.)

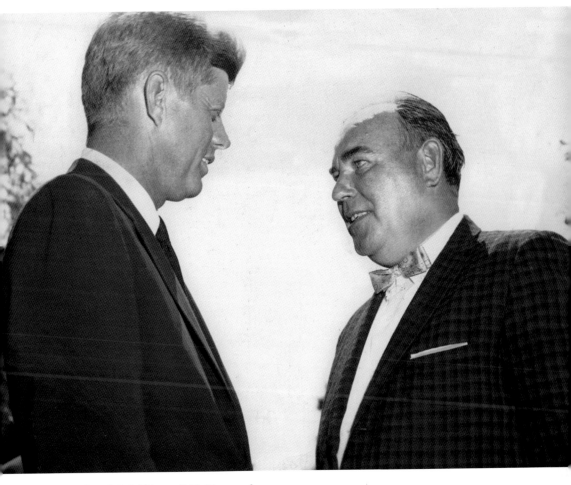

Counselor Patrick J. "Sonny" McDonough
The story goes that Governor's Councilman Patrick J. "Sonny" McDonough once said, "I hate it when a cop gives me $300. I don't know if he's stolen $200 or $700." When the story is told, it is meant to illustrate a means of doing business once common among the politicians of Massachusetts. Sonny McDonough could do you a favor. A favor would be done in return. He was a rogue among rogues, usually the smartest man in the room, always thinking several turns ahead in the game. Scituate found him on Second Cliff, smiling and enjoying life. A longtime member of the Scituate Yacht Club, he enjoyed the harbor from his boat, *Galway Bay*. In a history of the Scituate Yacht Club, Sonny McDonough is described as "the most political figure in the Commonwealth." Writing about McDonough, *Boston Globe* columnist Mike Barnicle remembered, "He could make you laugh, could make things happen and could positively make you appreciate what politics used to be: A business of helping people, and so what if something nice happened to Sonny along the way, too." (Scituate Historical Society.)

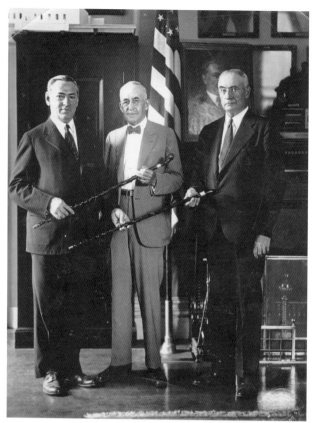

Gov. James Michael Curley
Often called the Irish Riviera, Scituate was a destination for the rising class of Irish politicians in Massachusetts. Foremost among them was James Michael Curley. His roaring clan enjoyed summers at Minot Beach, and the large home on the corner of Gannett Road and Hatherly Road was once theirs. Curley was a king to the Irish, and Scituate welcomed him with open arms. Labeled "the Rascal King" by historian Jack Beatty, Curley's career covered the period from the waning days of the telegraph to the bright lights of television. "Mayor of the Poor" read his campaign posters. Curley was a Robin Hood who vacationed in Scituate. Gov. Maurice Tobin would be another politico who would find a home on this coast. (Neil Gallagher.)

Rep. Nathaniel Tilden

Serving from 1939 to 1958, Nat Tilden was the chairman of the Pensions and Old Age Assistance Committee, a member of the agricultural committee, and most importantly, the chair of the influential House Ways and Means Committee.

He never missed a town meeting and while in the legislature cast more than 40,000 votes while filing nearly 200 bills, more than half becoming law. With his friendly manner, he held the respect of his fellows in Boston and gained the confidence and affection of his constituents in Scituate.

Born in Scituate and named for an ancestor who came from England in 1628, Nat lived on the family farm established in 1640. He was a lifelong farmer and an equally dedicated instrument for public service. (Scituate Historical Society/Bob Chessia.)

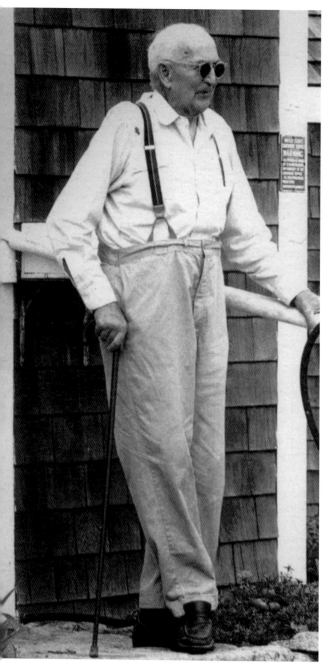

Selectman and Lightkeeper Jamie Turner

Jamie Turner served as a Scituate town selectman for more than 40 years. In that service, he offered his greatest work when he directed his wife to a Boston-bound train to stop an auction of the Scituate Lighthouse property. The town had been renting the light from the federal government but had not been notified of the auction. On his own initiative, Jamie sent Jessie to the lighthouse service office to halt the sale. The untold numbers of visitors to Scituate ever since have him to thank for the preservation of this siren site, this landmark of the town's heritage.

Jamie Turner was also a farmer; a 1907 *Boston Globe* article described him as ingenious in his market farming. With his foreman, Charles Volmer, he took his produce to market by boat each day. He was also a builder. The Sand Hills neighborhood that was once the Turner farm is dotted with stone-front houses built by Jamie more than 100 years ago.

In his later years, he moved into the lighthouse as its caretaker, joining his brother Tom Turner who owned the landmark "Jug in the Chimney" house on Lighthouse Road. Jamie and his wife, Jessie, were on the job the night that *Etrusco*, a 470-foot, 700-ton freighter washed up on the oceanside beach beside the light. From Saint Patrick's Day to Thanksgiving 1956, the Turners were to witness the spectacle that was the refloating of the *Etrusco*. Thousands upon thousands joined them each day in the series of events that put Scituate on the suburban map as a destination for so many young families in the next decade. If there was a man one could point to in town and say that he stirred the drink, all across his life, it was Jamie Turner. (Scituate Historical Society.)

Selectman Evelyn Ferreira

Part of an admired family and a standout on her own, Evelyn Ferreira was elected selectman with a simple message. She sought to take care of the families that built Scituate, the fishing families, the lobstermen, the police and fire and water and road workers. Controversial in that she was often a minority on the board, she nonetheless took her stand and made sure she was there for those whom she represented. Married to Anthony "Bud" Ferreira, Evelyn also welcomed the many athletes that worked out in the homemade gym Bud had assembled in their home on Tilden Road. Sister to two police chiefs and another officer and Aunt Mims to her many nieces and nephews, Evelyn Ferriera was not the first woman on the board (that was Patsy Proctor), but she was easily the most memorable. (Tucker Patterson.)

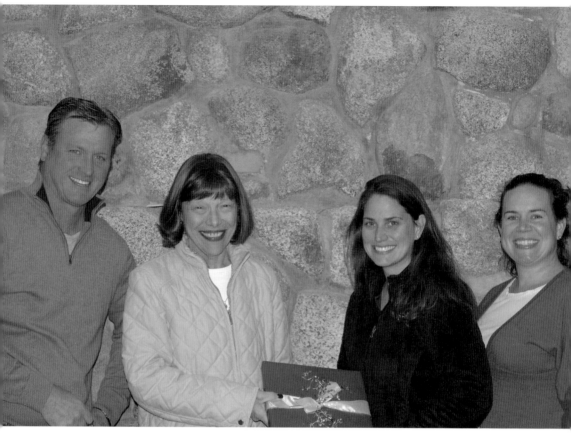

Selectman and Philanthropist Susan Phippen
Susan Phippen—pictured here second from left with Mark Flaherty, Jessica Lane, and Bridget Gilroy Mirachi—is a whirlwind. Volunteer extraordinaire, she accepts every challenge thrown her way. The Scituate Animal Shelter needs space to grow and to better serve the town, so Susan Phippen steps up. Every year, the annual drive to care for the less fortunate at the holidays occurs; Susan Phippen chairs the Scituate Community Christmas group. When the town was negotiating with the Massachusetts Bay Transit Authority, Susan Phippen served as liaison to the board of selectman. A selectman at one time and the president of the historical society at one time, Susan Phippen looks for opportunities to put her many talents to use and then offers them to any and every group that needs them. Small towns run on the efforts of whirlwinds like Susan Phippen. (Claire Flaherty.)

Historical Society President David Ball

His resume would resemble the phone book. Teacher, businessman, member of the planning board, volunteer to committees beyond counting, president of the historical society, Dave Ball has contributed his experience and his perspective to the town of Scituate to such a degree that his imprimatur on a project is enough to assure its approval. As president of the historical society especially, Dave Ball has overseen projects as diverse as the restoration of the Grand Army of the Republic Hall, the remodeling of the Little Red Schoolhouse, and the maintenance and repair of the renowned Scituate Lighthouse. In a time when the requirements of each of these tasks has called for an expertise in finance, bidding, building, and forecasting, Dave Ball has been a perfect fit. Past students recall his dry sense of humor, and he has been a perpetuating force in the annual trip of Scituate sixth-graders to Camp Bournedale. Be it on Cedar Point or at the Stockbridge Grist Mill, on a seawall in Humarock or greeting Flying Santa, Dave Ball is offering his best in a way that holds onto valuable traditions while moving the town forward. (Linda Martin/Scituate Historical Society.)

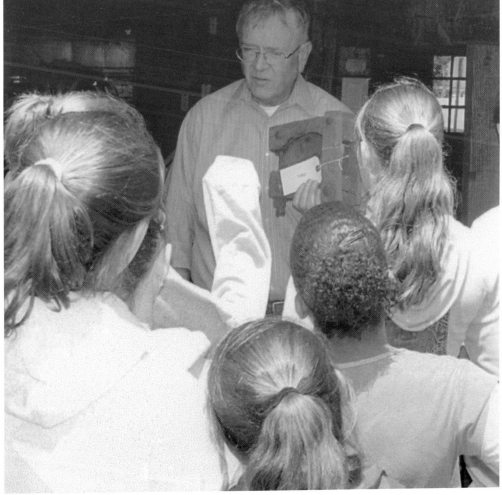

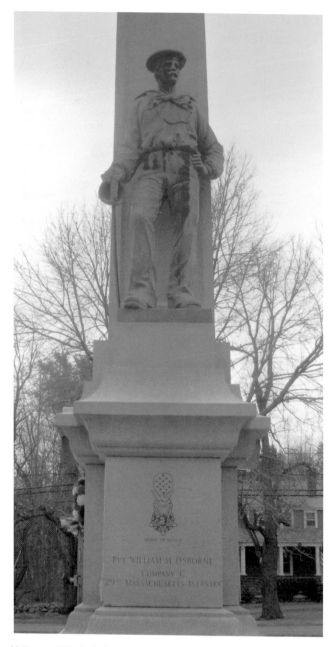

Medal of Honor Winner W.H. Osborne

The Battle of Mulvern Hill was part of the challenging Civil War Days of 1862. Young William Henry Osborne found himself wounded there, received some care from a field doctor, and returned to the fray only to be taken prisoner. For his service and dedication to his comrades, he was awarded the Congressional Medal of Honor.

Born in Scituate and having made his home in the historic lighthouse as an infant as his father served as keeper, Osborne would be remembered in the early part of the 20th century when the memorial on the town common included a statue of him. In the moments when the future of the United States was very much in doubt, William Henry Osbourne did his duty and then some. (Bob Gallagher.)

Town Clerk Pauline Guivens

When town clerk Bill Wade retired in 1964, Pauline "Polly" Fitts Guivens (having worked for him for 20-some years) first ran for town clerk. Winning by a two-to-one margin, she presided behind the desk in the clerk's office for 27 years, never losing another election. Polly loved "everything" about her job and always greeted people with efficiency, boundless energy, and smiling good humor. "It was never the same. I might do a lot of birth certificates one day, the next day dog licenses."

With her husband, Gus, they traveled widely in their motor home—to Arizona to see the spectacular balloons and Winnipeg, Canada to see the rodeo and many other places throughout the United States. They could be seen canoeing on the North River with the Wampanoag Paddlers and elsewhere. Polly was also an avid whist player, so no opportunity for fun was left out.

A townie to her toes, Polly knew everyone and often met them in far-off places. One time, she and Gus were in Denali, Alaska, (she wearing her "Scituate" sweatshirt) when someone hailed her. Turns out it was a fellow Massachusetts town clerk, also visiting Alaska. As reunions go, that may have topped the list! Everyone loved to be with Polly as she was fun to be with, had a warm heart, was down to earth, and had a great sense of humor.

Upon retirement, and between card parties, travel, and canoe trips, Polly volunteered at the town archives, lending her vast knowledge of Scituate families and town government to all who asked. (*Scituate Mariner.*)

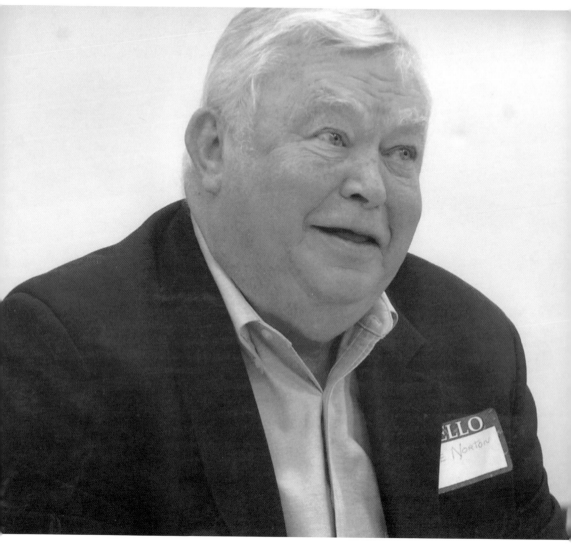

Selectman Joe Norton
After 30 years serving as a selectman in Scituate, Joe Norton is easily among the most recognized faces around town. Present at sporting events, retirement dinners, festivals, and wakes, Joe Norton is known as the member of the board who has his hand on the pulse of the town. Joe's institutional memory has served Scituate well as many new members have joined and left public service in his tenure. When the question gets asked about the genesis of a project or an idea, there is an excellent chance that Joe Norton has that answer at his fingertips. Sound policy, plans, growth, and generosity mark his career in public service. (Laura Sinclair/*Scituate Mariner*.)

CHAPTER THREE

Teachers and Preachers

Churches defined Scituate for a very long time. What faith one belonged to and the edicts of that faith that guided day-to-day life were central to understanding one's place in the world and what one might and must offer back to the community. The American public school offered a new home where students could get their letters and numbers right and assert themselves in the yard. The ministers and other clergy of the churches were complemented by the teachers and coaches and counselors of the schools.

Rev. John Lothrop had a difficult life made more difficult by a roiling debate inside his faith about the proper introduction of ritual to children. He would be imprisoned for his faith and seek relief here in Scituate. It was not to be.

Peter Nord and Christine Berman took on the challenge of bringing minds to life when they became English teachers. They preached that to be alive was to be engaged in the world. They challenged Scituate students for a combined 63 years.

Robert Corbin was also a teacher who pressed his students. His discipline was history and civics. It was his work outside the classroom though and with his family that might be his greatest contribution to the town.

Priscilla Ellsworth got students off to a good start. Barbara Murphy, Vincent Gilarde, and Katherine Becker took students to their graduation and college acceptances. In their stories there is a commitment to Scituate's children, young adults, and history.

Music is the legacy of William Richter. Do-wops, finger snaps, bass lines, and high notes have been pouring out of his classes, and the countless assemblies, recitals, and concerts he has overseen as music director for the Scituate Public Schools.

Jerome Crowley taught in nearly every school and taught the town to drive. Charles Lindgren was a Scituate pubic school teacher for 40 years. His talents took students to the stars as well.

These are the preachers and teachers.

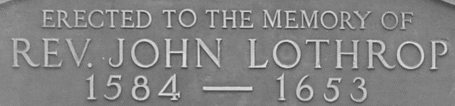

ERECTED TO THE MEMORY OF
REV. JOHN LOTHROP
1584 — 1653
AND SUCH FIRST SETTLERS WHO FILL
UNMARKED GRAVES IN THIS CEMETERY
AND AT THE "CALVES PASTURE"

MR. LOTHROP WAS PASTOR OF THE
CHURCH OF ENGLAND AT EGERTON, 1611-1623,
THE CONGREGATIONAL SOCIETY AT
SOUTHWARK, LONDON, 1624 - 1632
CONFINED NEWGATE PRISON, 1632 - 1634
SCITUATE, 1634 - 1639
BARNSTABLE, 1639 - 1653

HE WAS A GENTLE, KINDLY MAN AND BELOVED BY ALL WHO KNEW HIM

BARNSTABLE TERCENTENARY 1939

Memorial to Rev. John Lothrop

Going your own way in matters of faith is a tradition Scituate can lay claim to. The Reverend John Lothrop started this tradition when he ran afoul of other Congregationalist church leaders upon his release from the famous Newgate Prison. Lothrop would soon have difficulties in Scituate as well, removing himself to the newly founded town of Barnstable. At issue was what was a proper baptism. The difficulty of establishing farms and fodder for livestock in Scituate played a role as well. This rebellion over religious standards has become central to the American culture. The diversity that grows from the desire for choice and for an authentic spiritual life is central to the American experience. Reverend Lothrop set that standard for himself and for his congregations. Scituate was the home to that example before it marked the country. (Bob Gallagher.)

Peter Nord
To sum it up in bullets would be to say: Marine in Korea, 32-year English teacher, yearbook advisor, football coach, and mentor. And it would not come close to describing the presence and the impact of Peter Nord.

At his retirement dinner he claimed only one rule, "Teach 'em all." Speaking at graduation, he shared, "The greatest joy in life is to love," adding, "There will be times when you must learn to live with the hurt in that." Peter Nord was an inspiration to thousands of students, a true wit, a thorn in the side of the pompous, and much more than a few bullet points could ever capture. (Scituate Historical Society/Bob Gallagher.)

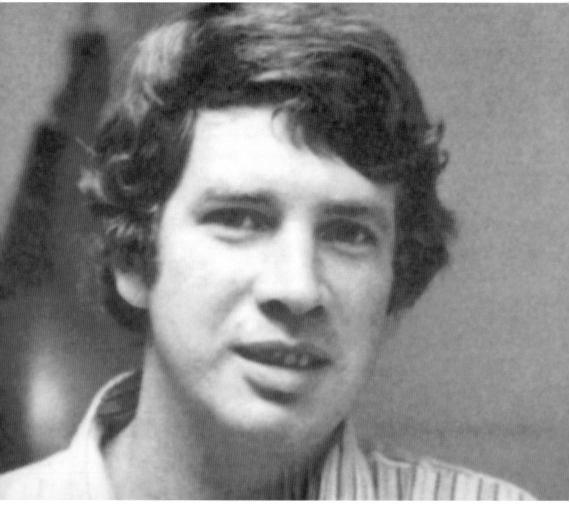

Jerome Crowley

The absolute definition of a soft-spoken gentleman, Jerry Crowley graduated from Scituate High School and returned to teach across the system for 36 years. Inheriting a driver's education class after the retirement of Les Faulkner, Jerry would go on to mentor young drivers for more than 25 years. The easy part was running the classroom preparation. The more memorable and challenging part were the driving hours required before the license test. Every 16 year old from Scituate got to know Mr. Crowley.

In his retirement Jerry Crowley was routinely seen bicycling in every neighborhood. He knew all of the families in each one. He could have faith that he was safe on two wheels because he had taught nearly everyone moving on four. (Scituate Historical Society.)

Robert Corbin

Robert Corbin was the sought-out teacher of US history and American government for more than 30 years in the Scituate public schools. Active in the Scituate Historical Society and in preservation projects throughout town, he set an example of scholarship and enthusiasm that carries forward to his work as a substitute teacher in his 70s.

Known especially for his course on the American presidency, Bob Corbin took a sabbatical in the 1970s to do primary source research at the Kennedy Library. He returned to teaching and shared that work with his students, raising the expectation and subsequently the standard for his discipline.

His biggest legacy may be the work done by his sons Bobby and David to restore the Grand Army of the Republic Hall on Country Way. The oldest public building in Scituate, the GAR was in danger of collapse when the Corbins stepped up to initiate the preservation process. His example of devotion to town and history was put into action by his sons, with a tremendous result. (David Corbin.)

Priscilla Ellsworth
A college professor once said, "Everything is in the beginning." Priscilla Ellsworth believed that when she opened the Beach Street preschool in Scituate. Getting kids off to a good start is what she has been all about over all those years. Taking the name from the house she lived in, the Beach Street School has gotten nearly two generations of Scituate's children on the road to good manners and sound habits. With the patience of Job and a smile, Priscilla Ellsworth and her remarkable staff of teachers have created the foundation for so much of the later success Scituate students have known. (Robin Chan/ *Scituate Mariner.*)

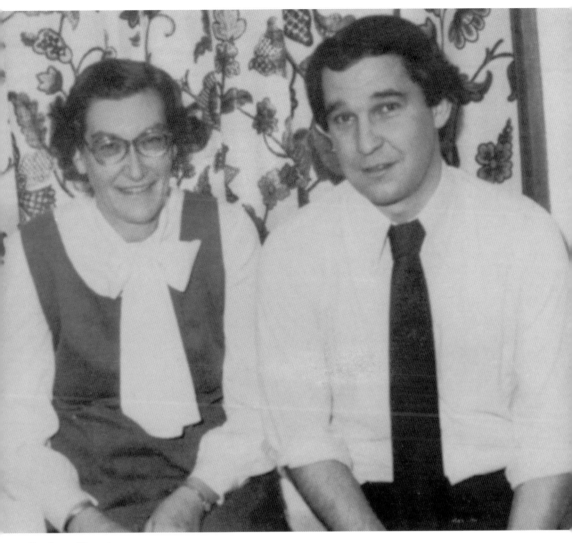

Barbara Murphy

A guidance counselor and a historian, Barbara Murphy (pictured with Bill Verseckes) offered her curiosity and her skills to the town of Scituate for more than 35 years. A historian of note, her books covered topics central to Scituate's heritage, from Irish mossing, to harbor life and the *Life of Captain John Manson*, to Scituate families. Miss Murphy knew the town inside and out. From the family in crisis to the bigger forces that marked generations, her skills were put to use soothing the former and teaching the latter. Barbara Murphy left a remarkable legacy of kindness and intellectual fervor for those who followed her to build upon. (Yvonne Twomey.)

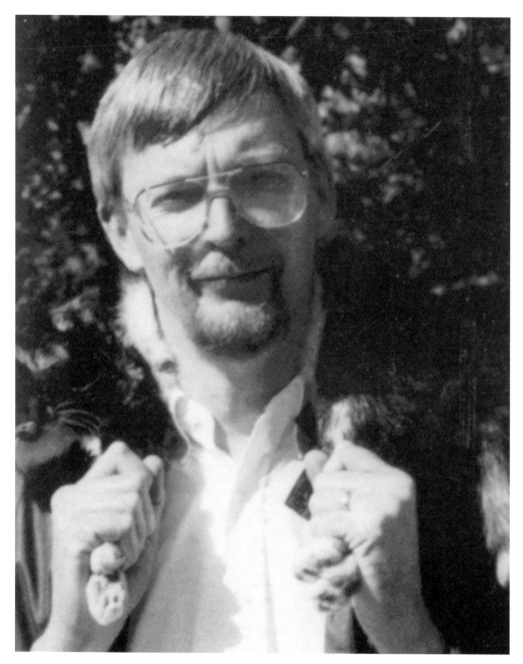

Charles Lindgren
As if 42 years as a Scituate science teacher were not enough public service, Charles Lindgren offered his considerable skills to NASA as well. Lindgren was one of four teachers to design lessons implemented on the International Space Station. Based on the interactions of students and astronauts, the lessons developed by this team of teachers would enhance the studies of students from grade five to grade ten. A mainstay of the Lester J. Gates Intermediate School, Charles Lindgren modeled lifelong learning for his students and for the whole country. Always looking for an outlet to share his love of the natural world, Charles Lindgren delivered in the classroom and in the stars. (Scituate Historical Society.)

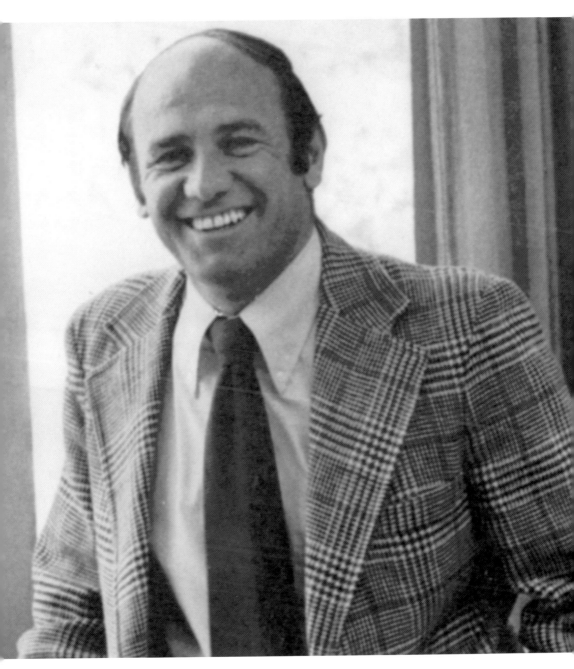

Vincent Gilarde
Vinnie Gilarde could be gruff on the outside but it did not take long to find out that he had a heart of gold. Filling nearly every possible position in the school department but superintendent, Mr. Gilarde was a coach, teacher, headmaster, and the acting principal at Scituate High from the 1960s to the 2000s. Vin Gilarde brought passion to the classroom and a desire to connect everywhere. Fairness was his calling card. It was also his booming voice that called out the names for so many years at graduation. Students knew they had arrived at that magical day when across the field their first, middle, and last were intoned by Mr. Gilarde. (Scituate Historical Society.)

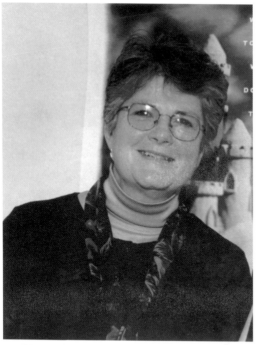

Katherine Becker
Kathy Becker was a guidance counselor upon whom two full generations depended for wisdom and direction. She was the patient smile that could find the hope in a bad teenage day. Frequently serving as a class advisor, her events always went off without a hitch. She had the tact needed when bringing news to a student that a reach school was a rejection, and she had the iron needed to hold the feet of a student to the fire if underachieving was a fact of life. All her students knew that Mrs. Becker was pulling for them to have their chance at happiness. (Scituate Historical Society.)

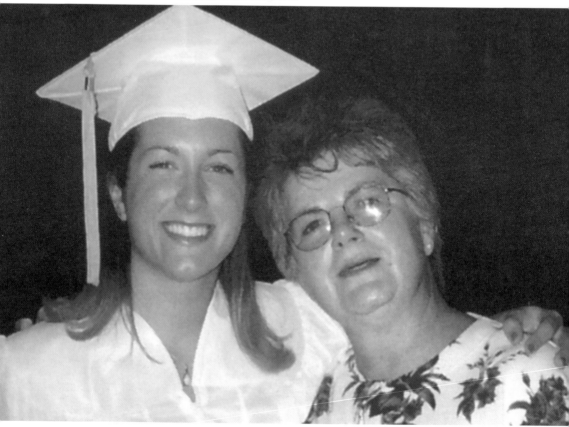

William Richter
Bill Richter puts a song in one's heart and a bounce in one's step. Chairman of the music department for the Scituate Public Schools, Bill Richter has influenced student after student over his long tenure. Bill has also served as the director of the Pilgrim Festival Chorus and as the music director for the First Trinitarian Congregational Church in Scituate. He is the man with the songs and an eye for talent. Humble and very, very fun, Bill Richter has been a bona fide genius in our midst for a long time. Scores of orchestra players, jazz musicians, singers, and song writers all carry evidence of his tremendous talent. (Scituate Historical Society.)

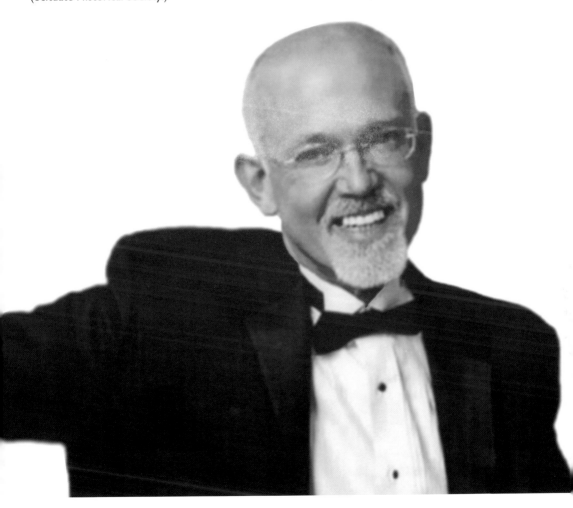

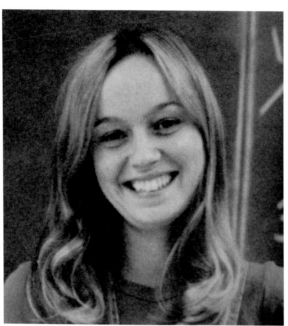

Christine Berman
As a Scituate High School English teacher and the advisor to the school newspaper, the *Scituation*, Christine Berman was in the middle of every event that happened at Scituate High School for more than 25 years. Long teased for an accent that brought a stereotype to life, Christine moved her students through the literature and the vocabulary and the writing exercises assigned with a spirit that made the work seem a blessing.

With the newspaper, her gift for fundraising and her eye for talent combined to win awards year after year. The *Scituation* staff saw her as a friend, a mentor, and an adult to trust and never cross. When she moved on to Cohasset High School, it was the end of an era. (Scituate Historical Society.)

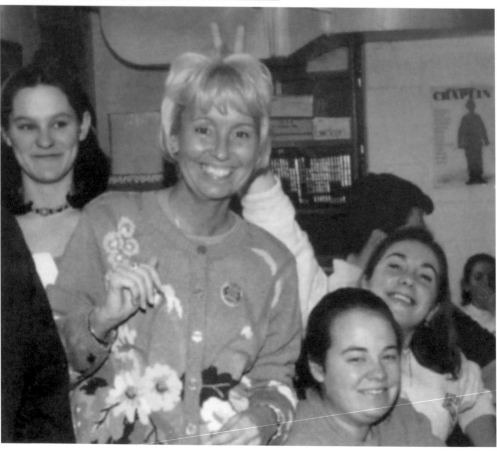

CHAPTER FOUR

The Clans of Scituate

The Men of Kent, Scituate's first families, are credited with the settlement of Scituate along the road that bears that name today. The cemetery on Meetinghouse Lane is home to the headstones of those first families. When the settlement spread out, other cemeteries were created to house new families and keep those memories close.

Family matters in Scituate. When it was a very small town there would be marriages, and the other celebrations that mark the passage of life would be shared by the extended families. Ties grew tight. The families included in this section are not the only ones that might have been chosen but they are indicative of different parts of town and different times in the town's history.

The Baileys and the Litchfields and the Bates are the old stock. Their roots go way back and their contributions are legion. "Service in Every Generation" is a simple way of capturing a motto for all three.

The Pattersons and the Monteiros and are newer to town but their contributions have been rich and the example they set profound. Work, education, generosity, and civic-mindedness are infectious qualities.

The Gates family and the Hoffman family might first be considered uniquely commercial players in the community. Each has had thriving business interests for a very long time. Digging deeper, though, reveals a devotion to town and to sharing prosperity that defines the best in small town life. Lester J. Gates was a visionary on transportation issues that continue to shape the South Shore. He was taken too soon. Richard Hoffman saw a need, filled that need, and shared the beneficence of his work with Scituate at every opportunity. His sons carried on this tradition, as did Lester's brother Lawrence and Lester's son, Harvey.

The Stewart family has been the first in Scituate athletics and Scituate public safety for more than 75 years. Their family tree is leafed with record holders and initiatives to secure the peace. They have been smarter, faster, and more diligent in their efforts than any family might be.

These are the clans of Scituate.

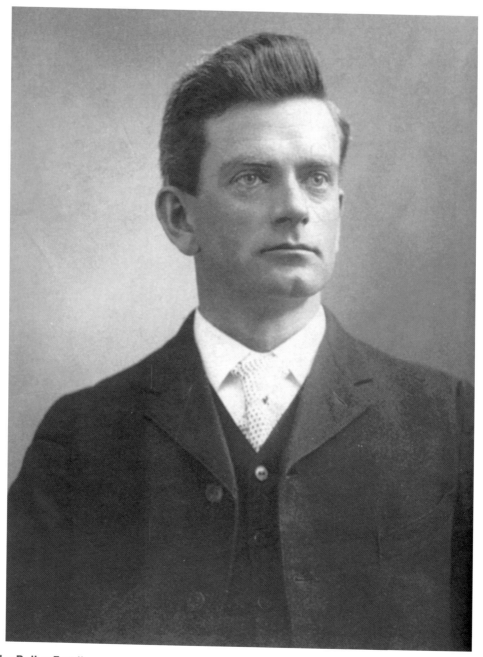

The Bailey Family
In Frank Capra's *It's a Wonderful Life*, George Bailey finds out what the small town of Bedford Falls would have been like had he not been there with his modest gifts and drive. Scituate has always known that it would have been quite different without its Baileys. The Bailey family has been a cornerstone in Scituate with members serving as selectmen, school committeemen, and representatives. Landmarks have taken the name too, from Bailey's Causeway to Bailey's Package Store to the Bailey Building in the harbor. From service in the Civil War to service in the building of neighborhoods, the Bailey family has been a constant that Scituate has needed to prosper. (Scituate Historical Society.)

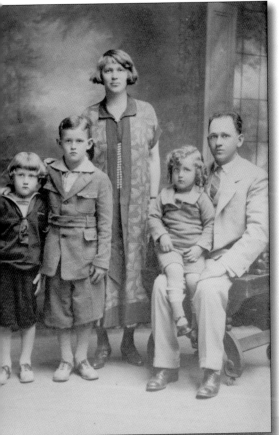

The Gates Family

The evidence is in the names and the titles: the Lester J. Gates Intermediate School; the Gates Clothing Store of North Scituate and the Harbor; the "Mayor" of North Scituate, Lawrence "Chick" Gates; Harvey Gates of the Scituate Community Preservation Committee. In every generation there has been a Gates to offer leadership and sound thinking. On issues of historic preservation, open space, public education, and business development, the Gates family members have been resident experts who put their time and energies to the making of sensible policy and practice.

Lester J. Gates was a state representative, selectman, and a school committee member. The historic record shows him at the forefront of South Shore issues like transportation and maritime management. Lester's brother Chick Gates contributed mightily to the conservation of open space in Scituate. (Harvey Gates/ Rudolph Mitchell.)

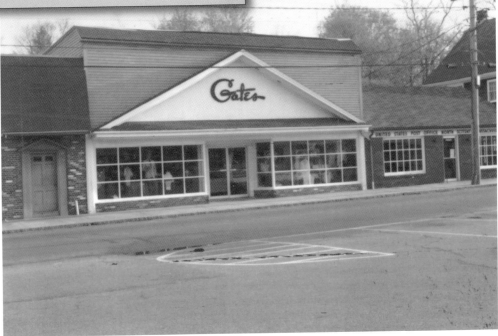

The Monteiro Family

The word was education, education, education. The Monteiro family believed in education and hard work and made Scituate the better for it. Guilherme was known as "Tony" to the Irish and the Yankees and as "Antoninho" to the Cape Verdeans. His example of determined effort and self-improvement would carry down to a remarkable legacy.

His children and grandchildren have accumulated 10 undergraduate degrees including four from Harvard, two from the University of Maine, one from Tufts, one from Northeastern, one from Dartmouth, and one from Salem State. His son Edward has a master's of business administration from Harvard; one of their grandchildren has a Juris Doctorate from Georgetown, one has a master's of science degree from Northeastern, and another from the University of Maine.

One of their sons, Manuel, returned to Scituate to establish the first bilingual program in the United States designed exclusively for Cape Verdean children. The program was acclaimed for its success in encouraging college attendance and graduation by Cape Verdean students. Manuel today is a dean at Boston University. Other members of the family manage extensive holdings in Cape Verde. The work continues. (The Monteiro family.)

Bates Family Plaque at Scituate Lighthouse
No family is more connected to the famous Scituate Lighthouse than the Bates family. The tale of Scituate Harbor and the Bates family's role in it begins with the first keeper, Simeon Bates, whose letters tell the story of a town growing up and stretching out, followed by the "Army of Two," Rebecca and Abigail Bates, whose quick thinking saved the town from a British invasion during the War of 1812. James Young Bates served as keeper and later went to find a fortune in the California gold fields. Bill Bates, a boat builder and World War I veteran, seemingly donated his last dime to see that the lighthouse was preserved as a town treasure, and Duncan Bates Todd had a talent for history and developed the story of the Fourteenth Lot. The Bates family cared about Scituate and in every action and choice that love came through. No family is better remembered, and all around town there are examples of their work. (Scituate Historical Society.)

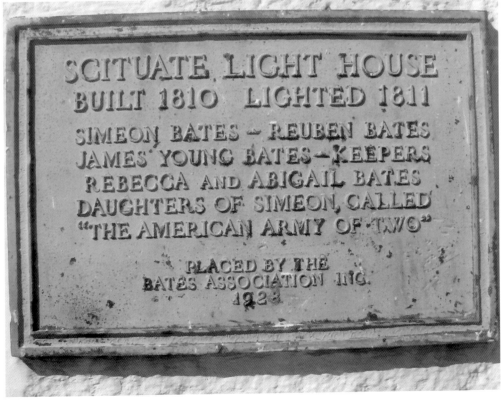

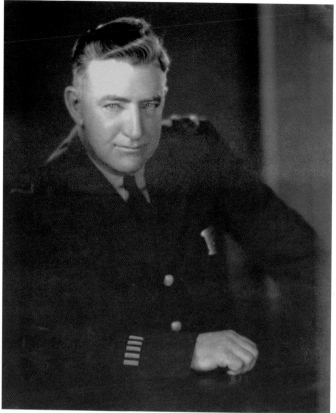

The Stewart Family

Michael Stewart, the arresting officer in the famous Sacco and Vanzetti case, came to Scituate as its police chief in 1925. His son John would become postmaster in North Scituate. John's son Walter would serve as fire chief. His cousin Brian serves as the current police chief.

Dominating the Scituate sports landscape for three generations, the Stewarts would coach at home and at places as renowned as Annapolis. Eventually serving as Scituate High School principal, Edward "Big Eddie" Stewart would be one of the winningest coaches in Massachusetts history. Public service has marked every generation with service in the military and the local police force. There have been detectives, athletic directors, and patrolmen in every decade. The Stewarts have shown their dedication to town and country and have set a standard in every type of endeavor. (Kim Stewart/Robin Chan/*Scituate Mariner.*)

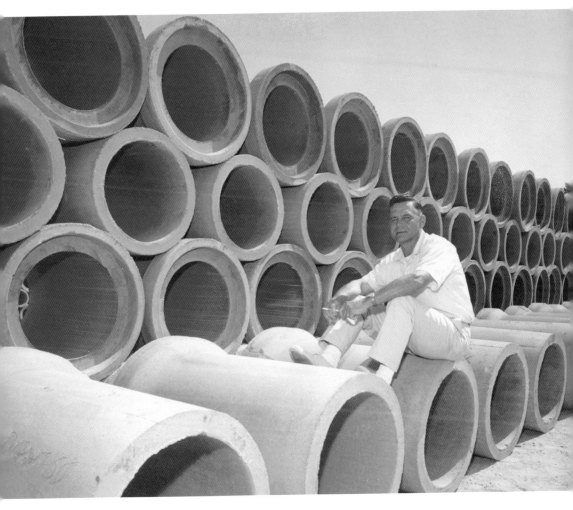

The Hoffman Family

Dig anywhere in Scituate and you will find an example of this family's work.

Started by William Hoffman Sr., Scituate Concrete Pipe built its business from a local concern to a regional and multistate operation and along the way found time to demonstrate again and again a public-minded generosity.

The lights at the Scituate High School football field are an example. The fundraising for the PJ Steverman roller rink is another. Providing funds for skate parks and hockey ice time are other examples, and the list continues out of the public eye where their private generosity regularly noticed a need and addressed it. Led in its second generation by Richard and William Jr. Hoffman, Scituate Concrete Pipe is known for its high standards and its loyalty to the town of Scituate. (Richard Hoffman.)

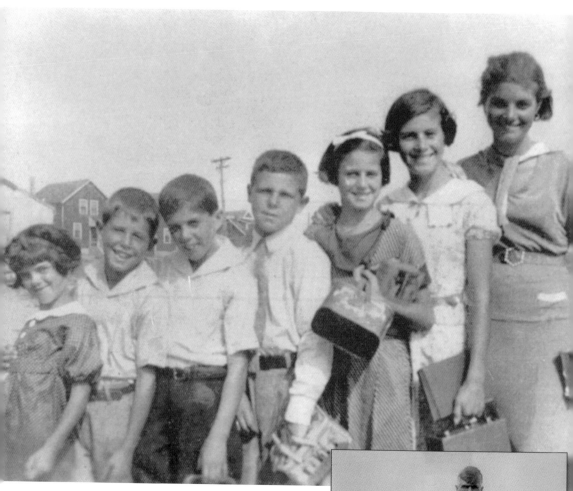

The Patterson Family

Who would have guessed when this picture was taken that there would be two police chiefs, another police officer, and a selectman all lined up for the first day of school? The Pattersons offered their service to the country in World War II and offered the town of Scituate their service when they returned. Gil and Charlie would be chief, and Tom an officer for more than 20 years. Evelyn would serve as selectman. The Pattersons were also mossers, fishermen, and lobstermen. They were seemingly as much at home on water as on land. In the 21st century, Mark Patterson serves as harbormaster. Gilbert Patterson Sr. is pictured at right. (Tucker Patterson.)

The Litchfields Gather a Crowd
Take away the Litchfields from Scituate and the town would have to shut down. They have been part of every aspect of town life from the very start. Blacksmiths, farmers, shop keepers, teachers, builders, mechanics—in every corner of Scituate there has been a Litchfield home and business. (Scituate Historical Society.)

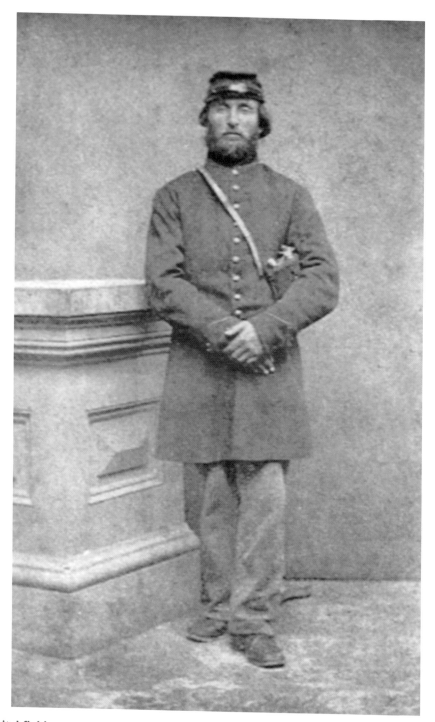

The Litchfields
Across all the years, the name has stood for honesty, hard work, loyalty, and ingenuity. A tour of the historic homes would find the Litchfield name on plaque after plaque. Scituate was built by a lot of Litchfields and a lot of Litchfields still sustain the town in its civic and economic life. (Scituate Historical Society.)

CHAPTER FIVE

Fixtures in the Business Community

Doing business in Scituate has always been a challenge. Too far off the beaten path to depend on numbers and limited geographically by being pressed up against the ocean, Scituate requires businessmen to work that much harder, that much longer, with that much more creativity and drive. Once a thriving center for ship building, later the home to the Irish mossing trade, Scituate more often than not now is a place people return to after working somewhere else. One result of this shift is that the economic life of the town is centered around services and trades. There is also a facet of maritime tourism built around a perfect waterfront and an excellent commercial and recreational harbor.

Jack Conway knew more about this than most. He recognized the potential in the South Shore first and became the most prominent name in real estate.

Lucien Rousseau was the anachronism. He continued to mine the ocean for the carrageenan that brought the Irish to Scituate in the 1850s.

Joan Noble and Ronnie Shone are local heroes. Each has taken a small space and made it the center of the neighborhood by providing convenience and fun.

Alden Finney and Paul Young shared First Parish Road. As automobiles took Scituate residents out of town to their jobs, Finney and Young stepped to the fore to provide the sales and service to keep them rolling on. Both were known for their sense of civic pride as well.

On one side of town, John Fitts lived as a farmer and a businessman. Fitts Mill is pronounced as one word as it has become the lynchpin of the Greenbush section of town. On the other side of town, Gil Wilder managed his garage and found a way to do so much more. By serving as selectman and by asserting that there would be a strong business center in North Scituate too, Wilder helped shape the town.

Allen Wheeler contributed to the infrastructure and the overall development of Scituate as a contractor and bank president. Neighborhoods went up and businesses were created with his imprimatur. Few got rich; all made a difference.

Jack Conway

Homes, business, rental properties, development—what do they all have in common? Jack Conway.

Jack Conway was the first and last word in South Shore real estate from the mid-1950s until his passing in 2012. "Conway Country" was not just a slogan; it was a fact of life. With offices in every town and connections in each bank, the planning board, and the zoning board of appeals, Jack had his hand on the pulse of the business life of Scituate and the whole south of Boston scene.

Charities were his other specialty. With charisma to burn, Jack charmed and redirected the energies of any group to a greater good. Countless families lived better, often without any sense of their benefactor. The one-time sports writer had found a way to compete in business and still be a team player. (Scituate Historical Society.)

Joan Noble

The conversation usually went like this: "Where did you get that amazing, unique, one-of-a-kind, must-have-one-myself item?" The answer: the Quarterdeck.

Joan Noble's Quarterdeck has been a destination stop in Scituate Harbor for 45 years. Gathering an eclectic mix of nautical and Army/Navy store clothes and bags, side-by-side with jewelry, postcards, metal signs, and scrimshaw, Mrs. Noble made it possible to answer a last-minute invitation to a birthday party or anniversary with the perfect gift. Used as a location for the film *The Witches of Eastwick*, the Quarterdeck served as the fictional home for an otherworldly Cher. Mrs. Noble and her dog Holly have seen changes roil the harbor and have kept the faith throughout. (Julie Gallagher.)

Ronnie Shone

A Scituate tradition since 1941 when his father took over from the Withem family, Ronnie Shone has been smiling and selling and listening and gossiping at his crossroads country store since he was seven years old. Much more than a place for kids to go when cutting class, many have recognized Shones as the place they did their growing up. Be it flirting as a freshman, picking up breakfast as a sophomore, or grabbing a snack after a game, students love going to Shones, and Ronnie is that steady presence that welcomes them and keeps them honest.

Renowned as a long hitter in golf and as an avid fisherman, Ronnie Shone has been in place, day after day, holiday after holiday. The year 2012 marked his 61st Christmas in the store where his grandmother once managed the local mails. (Bob Gallagher.)

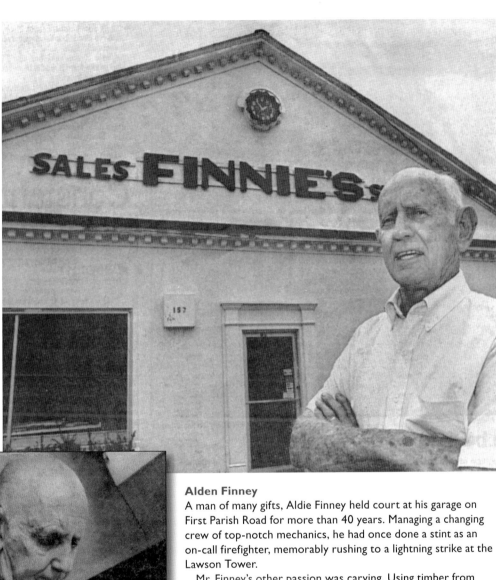

Alden Finney
A man of many gifts, Aldie Finney held court at his garage on First Parish Road for more than 40 years. Managing a changing crew of top-notch mechanics, he had once done a stint as an on-call firefighter, memorably rushing to a lightning strike at the Lawson Tower.

Mr. Finney's other passion was carving. Using timber from unusual sources—the Old Howard Theater, for one—he would do wood carvings of ducks. He created a remarkable collection in his time, working in collaboration with his wife Olga. When Aldie Finney was involved, the best possible work got done, on the cars and on the carvings. (Scituate Historical Society/ *Scituate Mariner.*)

Paul Young's First Garage

If wheels and deals were on one's mind, Paul Young was the man to see for more than three generations in Scituate.

Legendary for his unsolicited compassion and his common sense, Paul Young established his first car dealership in Scituate Harbor in the 1930s. His father, Harold, known as Pickles (and who doesn't love a guy whose dad was called "Pickles?"), owned the bowling alley next door to the garage and what was later known as Pitcock Farm on Kent Street. Later moving to First Parish Road, Paul was no-nonsense and understood that the long buck was far better than the quick one.

It was said of Paul, "He always had a set of tires and a gallon of gas for you." He also endowed one of the most generous scholarship programs at Scituate High School for many, many years. (Steve O'Brien.)

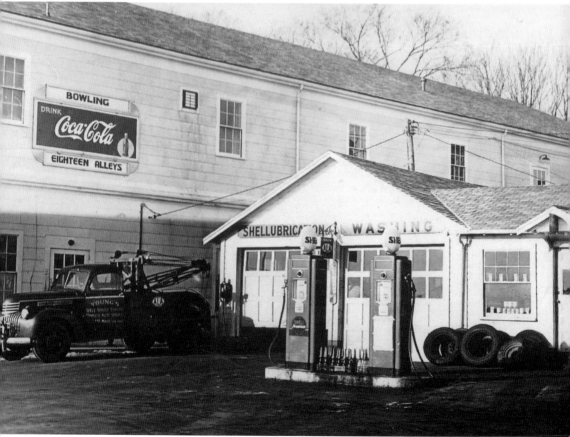

Gilman Wilder

The man to see for more than 50 years in North Scituate, Gil Wilder was Scituate Citizen of the Year, selectman, benefactor, businessman, and storyteller extraordinaire. Owner of the Wilder Brothers Garage at the corner of Country Way and Gannet Road, he was the anchor in an ever-changing marketplace. Need the news? Go see Gil. Need something done? Go see Gil. Want some advice? Go see Gil. Need a laugh? Gil was your guy for that too.

Whether it was serving as master of ceremonies during breakfast at Jamie's or overseeing the Monday Morning Men's Club, Gil Wilder brought fun and common sense to the table. (Scituate Historical Society.)

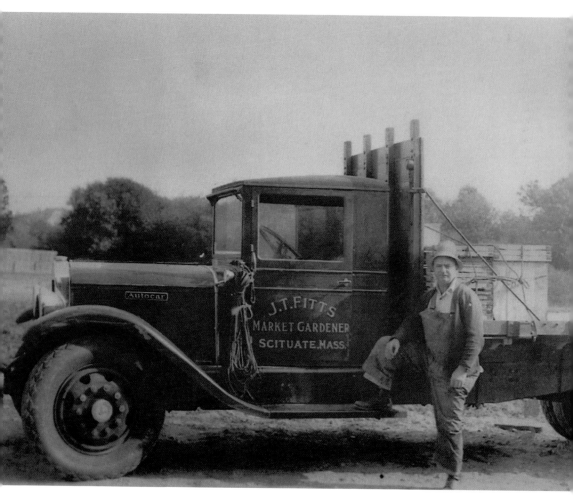

John Fitts

On the far side of town from where Gil Wilder held court, John Fitts worked. And he worked. And he worked. A farmer and the owner of the still-operating Fitts Mill, John held the place in Greenbush of the man to see. A lover of old cars and a longtime member of the South Shore Antique Auto Club, John Fitts knew how to fix anything and had seen all the styles come and go. Mr. Fitts was also a master landscaper. He could be seen meticulously maintaining his yard in every season. It was thought that a leaf or an acorn would think twice after Mr. Fitts had done his fall cleanup and that the snow would not fall on a path he had shoveled. (Scituate Historical Society.)

Lucien Rousseau

Inheritor of the mantle once held by Daniel Ward, Lucien Rousseau was the Irish mossing industry in Scituate during the 1960s and 1970s. With a system of dory rentals, machines he improvised, and the strong backs of Scituate's mossers, Rousseau organized the daily harvest of carrageenan from the rocks of Old Jenkins and the Long Ledge.

A native of France, Lucien Rousseau graduated from Scituate High School and attended Wentworth Institute in Boston, earning a degree in mechanical engineering, drafting, and blue printing. After serving in the Air Force, he returned to Scituate in 1943 and purchased Fred Conroy's Irish mossing business. His engineering skill enabled him to improve the original mossing rake, and he designed and built hoisting equipment to move wet moss from dories to trucks. If someone wanted a summer job that would get them in amazing shape, Lucien Rousseau was the guy to look up.

Rousseau also served on the Scituate Town Waterways Commission, and the mossing dock in Scituate Harbor is named for him today. A Scituate Chamber of Commerce Citizen of the Year in 1982, Lucien Rousseau was an original from high to low tide and from handle to blade. (Joan Noble.)

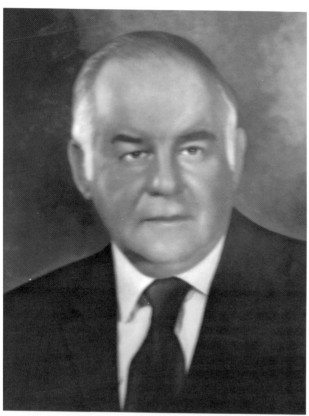

Allen Wheeler

Children in Scituate learned Allen Wheeler's name when they were young. Wheeler Park, a housing complex for the elderly, bears his name. His portrait was the most prominent on display at the biggest bank. His role in refloating *Etrusco* from the beach at Cedar Point was legendary. The establishment of Etrusco Associates to serve the temporarily disabled was pushed forward by his energy. All over Scituate, gas lines were installed, ball fields were built, developments were financed, and mortgages were advanced with Allen Wheeler at the wheel. Allen Wheeler employed local workers, and gave back to the town as much as anyone ever did or ever has since. (Scituate Federal Savings Bank.)

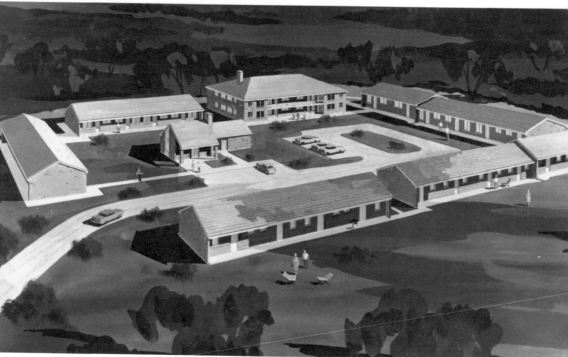

CHAPTER SIX

Talents in the Arts and Media

Artists have been drawn to Scituate as a resource and as a home. Many have started out there and later gone out into the "marketplace of ideas." Authors, playwrights, poets, actors and actresses, photographers, and painters have passed through, settled down, or returned from time to time to renew their hometown ties. Artist colonies were established on the cliffs of Scituate more than 100 years ago. In the modern era, talents of every type have been born here and have moved here to tell stories, illustrate, direct, produce, act, practice journalism, and teach the arts in the spirit of Henry Turner Bailey and Sally Bailey Brown.

Nick Flynn has hit the big time with his work in poetry and in memoir. Peter Tolan has created stage works, films, and television shows with fantastic success. Projects with Billy Crystal, Denis Leary, and others have given him a reputation for can't-miss hits.

Peter Mehegan was the standard bearer for a new kind of television journalism for more than 20 years. Paul Szep is almost without peer in the field of editorial cartooning. He is routinely mentioned with Gary Trudeau and Herblock.

In his time and even now, Charles Kerins is compared to the greatest illustrator of them all, Norman Rockwell. Mat Brown has a place at this table for his diverse talents in sharing Scituate's history and using his artistic talent commercially.

Authors Jerry Palotta, Richard Wainwright, and Dean Morrissey have called Scituate home and used the local setting in their work for young people.

Mark Goddard, Bates Wilder, and Taylor Stanley started acting careers on the stage at Scituate High School.

Mike Coyne and Richard Toomey have found in the local landscape fuel and subjects for their gift with the brush and the pencil.

Ward Hayden is a Scituate boy turned rockabilly musician.

Authors Claire Cook and Jacques Futrelle have written stories that have endured and will endure as they tell us something about human nature from unique points of view.

Creators, storytellers, artists, and teachers—these are talents.

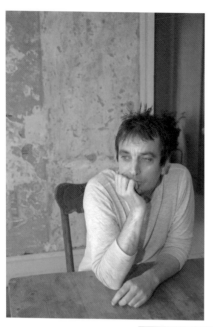

Nick Flynn

With a sad, small-town story and a big-time, big-town talent, Nick Flynn has moved from Third Cliff in Scituate to New York City and Paris. A poet whose books *Some Ether* and *Blind Huber* first brought him to the attention of the wider literary world, Nick is best known for his memoir, *Another Bullshit Night in Suck City*. The film version, *Being Flynn*, starred Robert DeNiro as Nick's estranged father whom he meets while volunteering at the Pine Street Inn for the Homeless.

As a professor in Houston, a poet in Brooklyn, or an essayist in the *New Yorker*, Nick Flynn brings a critical voice to his times and to the public and personal challenges of those times. (Dion Ogust/Nick Flynn/ Scituate Historical Society.)

Peter Tolan

Another local boy made good in Hollywood is Peter Tolan. An acclaimed writer for television and for film, Peter Tolan started out as a member of the Scituate High School drama club. After high school, he was the founder of the Young People's Summer Theatre, which quickly became an admired institution in town. In college, he attracted the attention of talent scouts, which led to roles with improvisation groups and an off-Broadway debut as part of a two-man show of his own sketch work.

Murphy Brown, Rescue Me, Analyze This, and *Analyze That* are the best-known efforts in the creative life of Peter Tolan. In 2011, he made his directorial debut with a semi-autobiographical film called *Finding Amanda.* He has worked with Robert DeNiro, Denis Leary, Billy Crystal, and Harold Ramis and is one of the sought-out names when a project is in need of a comedic twist.

In 1993, Peter returned to Scituate High School for commencement. As the featured speaker, he tore the house down with his reminiscences and his advice. Among the list, take the girl of your dreams to the lighthouse with a sub from Maria's—if she isn't wowed, she isn't the girl of your dreams. (Peter Tolan.)

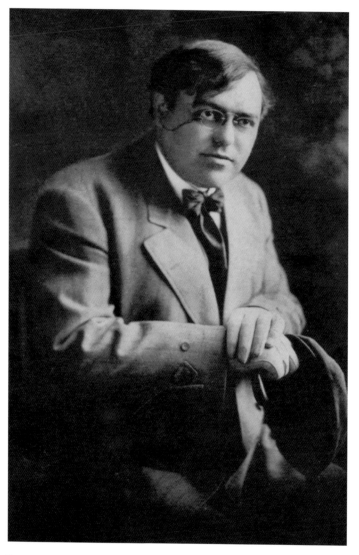

Jacques Futrelle

What do you get when you combine the brain of Sherlock Holmes, the setting of a Spencer novel, the romance of an ocean liner, and the most famous tragedy of the early 1900s? The story of the Thinking Machine, the creation of Scituate's own Jacques Futrelle.

Originally from Georgia and a sports writer for different newspapers, including the *Boston American,* Jacques Futrelle made his home at "Stepping Stones" at Second Cliff. He created an all-American version of Conan Doyle's Holmes in 1905 with the appearance of Augustus S.F.X. Van Dusen. Relentlessly logical, Van Dusen got his nickname, the Thinking Machine, from an outcry during one of the stories when he defeated a chess grandmaster after only one lesson. Futrelle wrote more than 50 Thinking Machine stories until his untimely passing aboard the *Titanic* in April 1912. In his last moments, he was described smoking alongside John Jacob Astor. His last Thinking Machine story would appear posthumously, "The Lady's Garter."

Futrelle was not to be forgotten however. He would be the protagonist in stories by Max Alan Collins, *The Titanic Murders.* His final place on the stage would be in the place of a genius detective like the one he created. (Scituate Historical Society.)

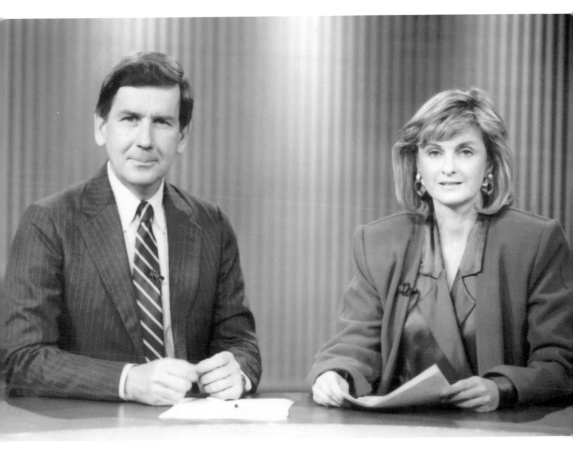

Peter Mehegan
Veteran journalist Peter Mehegan started out as a Dorchester native and like so many found himself summering in Scituate. Moving there as a teenager, Peter adopted the town as his own and settled down. Moving from a reporter's role with WBZ and WCVB, Peter Mehegan took his love for small town life to the WCVB television program *Chronicle* for more than 20 years.

"The Old Chevy" was his vehicle to the main streets and back roads of New England and much of the United States. A restored 1957 Bel Air, the Old Chevy took Peter to the stories off the beaten track in small towns just like Scituate. These vignettes were *Chronicle*'s mainstays. Viewers never knew what they were going to learn and how they might be surprised. One day it might be the singing barber, the next, a home in the shape of a cupcake. In every story, there was a slice of humor and humanity. The car became a prop because Peter was the real vehicle.

Retiring in 1998, Peter left *Chronicle* to enjoy his grandchildren, his hobbies, including opera, and to let his imagination roam without the camera on. He has played a role in Fourth of July ceremonies in town, reciting excerpts from Scituate's Declaration of Independence, which preceded the declaration the Continental Congress approved on July 4, 1776, by several months. Part teacher, part adventurer, always a real good guy on the main street or back road, Peter Mehegan is a class act no matter what role or what setting. (Scituate Historical Society.)

Paul Szep

The trick was to find his daughter Amy's name hidden in the cartoon.

Paul Szep won the Pulitzer Prize for political cartooning, twice, in 1974 and in 1977 while on the staff of the *Boston Globe*. The editorial page was remade as a destination because of his provocative and insightful work from 1967 to 2001. No one captured the eccentricity of Richard Nixon like Paul Szep.

Each day a Szep cartoon appeared in the paper, scores would search it for his daughter Amy's name hidden in the image. There was a lesson there on the issues of the day, and there was a dedication to family there too. (Paul Szep.)

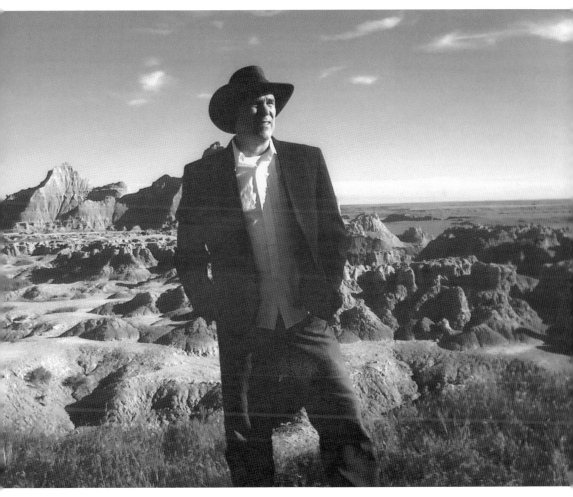

Bates Wilder

The face is the first feature noticed. It might have been on a commercial. It might have been on the sideline at a soccer game. The voice is the second feature. It might have been heard when watching a cartoon. It might have been heard in line at Marylou's. Bates Wilder performs, directs, and writes because he has a talent that cannot be denied. It does not matter if he is working with students or working with professionals, Bates looks for those opportunities to advance the story and to advance the talent of his collaborators. As drama coach at Scituate High School, he encouraged the club to write and perform their own work. These efforts were award winners each time. His own stage work has been recognized with awards for best actor and best supporting actor in Boston during 2007 and 2008. As a teacher at Emerson College and at Boston University, Bates has brought his humor and understanding of the complexity of human nature to students from around the country. Scituate is proud to claim him and always looks forward to his next performance. (Bates Wilder.)

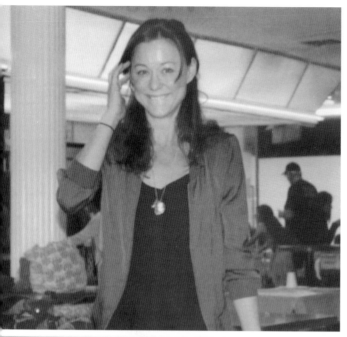

Taylor Stanley

Taylor Stanley (born Michelle) knew she wanted to be an actress from the start.

A chance to play the body double for Sarah Jessica Parker in the film *Hocus Pocus* started things rolling. When Arthur Miller's *The Crucible* was set on the North Shore, Taylor auditioned for a part as one of the village girls who set the horrible Salem Witch Trials in motion. She was in nearly every scene.

Her work on *The Crucible* led to a move to New York and a featured role in *Spin City* with Michael J. Fox. Soap operas, plays, and films followed. Her longest lasting role was playing Remy Woods on *Another World*.

More recently, Taylor is a mom with two young kids to care for. She shines in this private role as she has shined in so many others. (Taylor Stanley/Scituate Historical Society.)

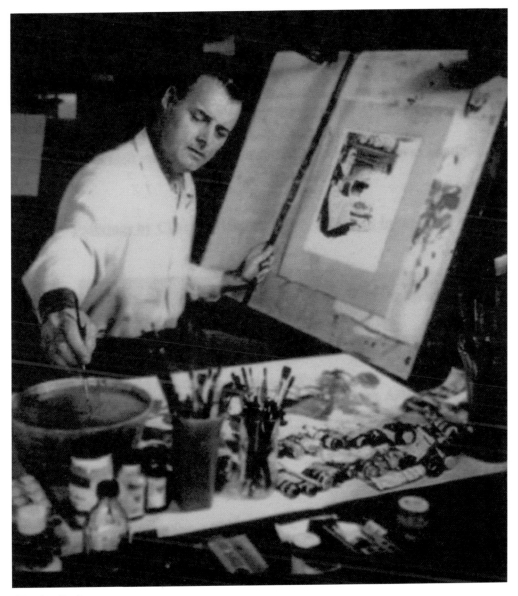

Charles Kerins

An illustrator often compared to Norman Rockwell, Charles Kerins painted the famous and the everyday with equal flair. His portraits of President Kennedy and Cardinal O'Connor and his work on Red Sox yearbooks capture a time and a place perfectly. Mr. Kerins used a great number of his neighbors as his models. There is still debate about who is who in his work. Named one of America's top 100 illustrators, Charles Kerins executed work for Converse, Schrafts, Milton Bradley, and Hood, along with the *Saturday Evening Post*, *Look*, and *Life* magazines. (Scituate Historical Society/Kerins family.)

Mat Brown

Raconteur. It is an old word, not used all that often anymore. The dictionary offers that it means "skilled in the telling of stories." In pen and ink or in word, Mat Brown is a raconteur.

Born in Scituate and namesake to the longtime highway supervisor, Mat Brown started hearing stories while on town crews. The tall tales and stories he has shared all seem to circle back to those he heard riding around in a truck or pushing a broom or gathered around a brown-colored drink in a local saloon. With an ear for the cadence that keeps the listener moving in, Mat can surprise even the most jaded audience into asking for more.

Also a gifted cartoonist, Mat Brown left a position in teaching at Scituate High School to go to work for Jerry Ellis and Building 19. His cartoons capture an ironic and irreverent voice that mirrors his storytelling.

A Scituate Historical Society trustee, elected to the committee that revised the town charter in 1978, and a member of the 375th anniversary committee, Mat Brown has given back to the town in a host of ways. As husband to Rosie and father to Marybeth, Matthew, and Amy, Mat continues to listen and continues to draw. The stories keep flowing from this raconteur. (Robin Chan/ *Scituate Mariner.*)

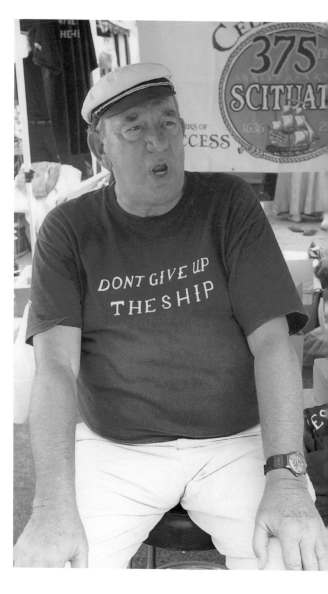

Claire Cook (OPPOSITE PAGE)

When Nick Flynn sold his autobiographical *Another Bullshit Night in Suck City* to the movies, one might have thought he would have broken some new ground in a town as small as Scituate. In fact, that ground had been broken by Claire Cook when her novel *Must Love Dogs* was sold to Hollywood a few years earlier.

A one-time fitness teacher and dance choreographer, Claire started her writing with the local weekly. When novels began to swirl around in her head, she took the time she used waiting for her daughter to finish swimming practice in the early hours of the morning to write her first novel, *Multiple Choice*.

Author of five more novels since, Claire is a role model for moms who set aside their talents for a time and later return to them with fabulous success. (Peg Patton/Front Street Book Shop.)

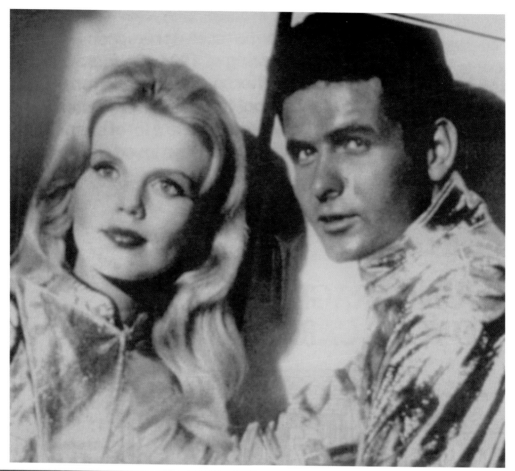

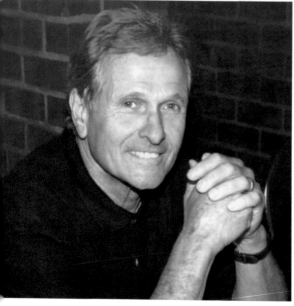

Mark Goddard

From college to television to teaching, Mark Goddard has followed an unusual career path. Encouraged to try acting in college, he found himself in the cast of *Lost in Space* as Major Don West and in various soap operas, including *General Hospital*. Leaving performing behind, Mark took the turn that led him to teaching. In his memoir, *To Space and Back*, he shares the ups and downs of a career in the bright lights and a greater satisfaction in the classroom. As a special education teacher at the F.L. Chamberlain International School in Middleboro, Massachusetts, Mark brings his wide experience to the needs of a student population that cannot wait for the next lesson. (*Scituate Mariner*/Scituate Historical Society.)

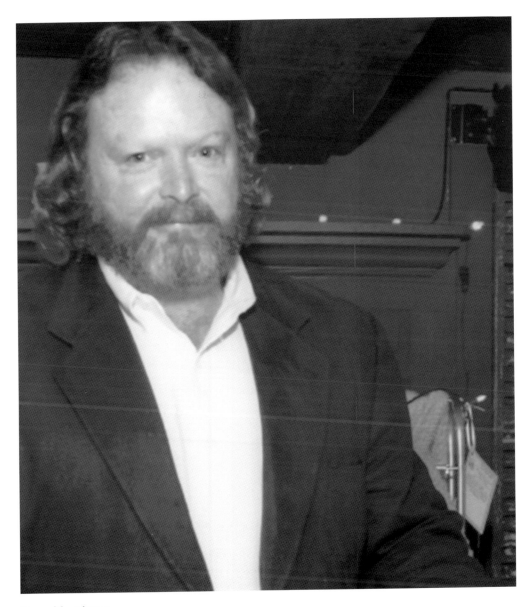

Dean Morrissey
Scituate is lucky to be home to many different individuals blessed with an awesome gift. Dean Morrissey has more than one. A brilliant illustrator and a deeply imaginative writer, Dean can transport anyone with his prose or paintings. In an interview, he offered this explanation: "Sometimes, a painting suggests another realm, a place of peculiar machines, creations, and characters which can exist and function only when the imagination is engaged. By combining diverse elements—light, shadow, color, and human warmth—I try to create an accessible universe." In books like *Ship of Dreams* and the *Song of Celestine*, he does just that. The winner of numerous awards for his work, Dean keeps sending his gifts out into the world for others to learn and to grow. (Scituate Historical Society.)

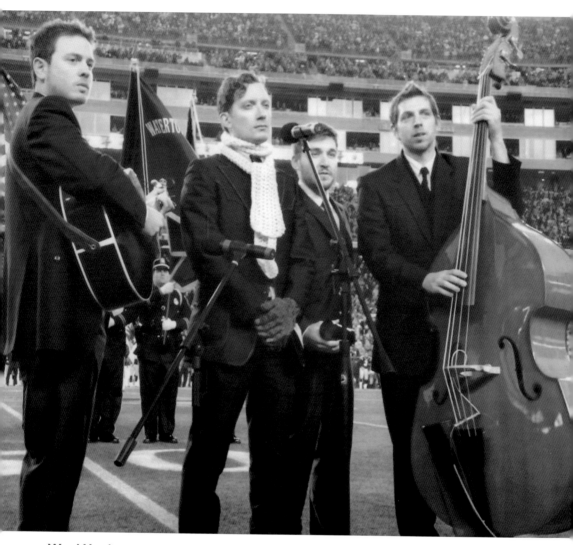

Ward Hayden

Scituate is not often associated with country music. In fact, if a Scituate native wanted to claim much of a musical influence, the bells of the Lawson Tower might be all that could be labeled unique. With his band Guns, Girls, and Glory, Ward Hayden (second from left) has overcome this liability to travel across the country as a headliner and as an opening act for some of the music business's biggest names. Starting in high school with a homegrown band, GGG discovered an unusual sound that pushed it to victories in the famed WBCN Rock 'n' Roll Rumble and Independent Artist of the Year at the French Country Music Awards. Inspired by the music of Hank Williams and others, Ward Hayden is just getting started as a songwriter and a performer. (Ward Hayden.)

Jerry Pallotta
Countless parents and teachers have come to depend on the work of Jerry Pallotta to help them teach young children difficult concepts. Born in Boston but summering on Peggotty Beach, the Georgetown-educated writer has a knack for taking the highfalutin' and breaking it into kid-sized bites. He has taken on ideas as varied as birding and bugs, along with counting and alphabet books. *The Icky Alphabet Bug Book* has sold more than one million copies. His story of a day out in a mossing dory, *Dory Story*, has been a Scituate must-have from its first day in print. With a gift for words and for making connections, Jerry Pallotta will keep on writing and teaching for years to come. (Peg Patton/Front Street Book Shop.)

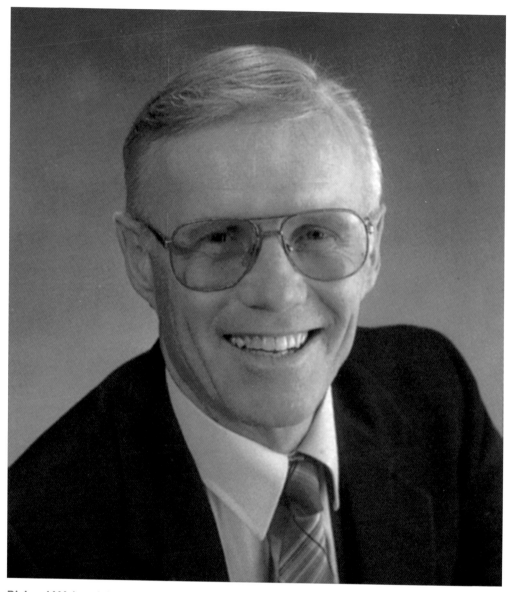

Richard Wainwright
The books of Richard Wainwright offer an insight into the man. Thoughtful, caring, with a wide experience and deep faith, Dick Wainwright creates tales of struggle, confusion, epiphany, and connection. Originally a Needham native, Dick settled on Cedar Point in Scituate after a long career as a teacher, coach, school administrator, and inventor. His stories have touched people all over the world and he has deep connections in South America and Central America where he established business ties during his inventing years. He has most recently authored the *Tale of The Scituate Lightkeeper's Daughter* with all the proceeds from the book supporting the Scituate Historical Society. (Richard Wainwright.)

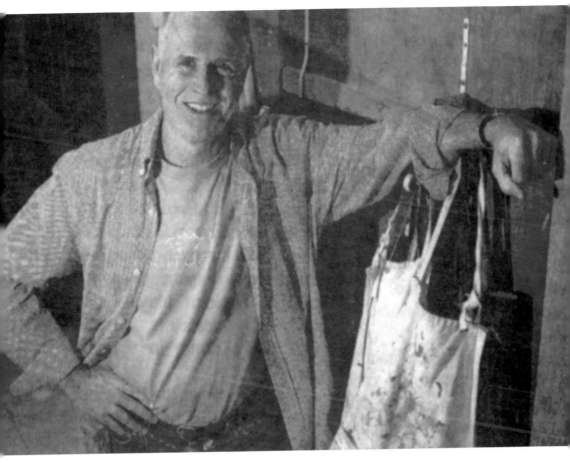

Richard Toomey
In a town that was home to pioneer art instructors like Henry Turner Bailey and Sally Bailey Brown, Richard "Skip" Toomey has managed to break new ground with his 40-year career as an art instructor in the Scituate Public Schools. His work is notable for its vibrant color and its subtle storytelling. His work with children has the same qualities. He was a source of tremendous energy and vivacity in the classroom, all the while modeling the quiet and reflective side of the human experience. Kids noted that complexity, and it called out of them a desire to move closer, listen more intently, and demonstrate the lessons in their work. Skip is also a lot of fun to be around, and that's nothing to scoff at either. (*Scituate Mariner.*)

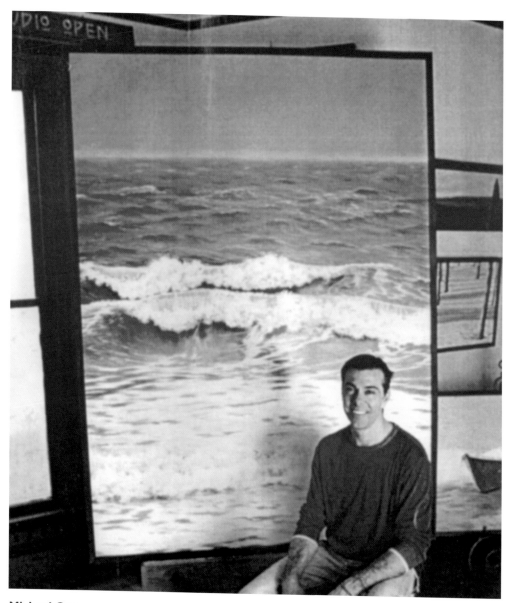

Michael Coyne

First coming to prominence as a muralist, Michael Coyne has established himself as a gifted landscape artist. Commissioned to execute a mural of 20th-century American history, *Landscape of a Nation*, Michael immersed himself in the project, finally realizing a work of three 18-foot-by-six-foot panels. He later tackled a similar piece on Boston sports teams. His work is unusual for its photographic nature and its scale. His landscapes take the viewers to the marshes and the beaches of Scituate. One can hear the birds singing and the waves rolling. His eye for color and the action in nature is superb. Michael's work will last. He has only scratched the surface of his talent. (*Scituate Mariner.*)

CHAPTER SEVEN

Competitors in Athletics

Small-town life often revolves around the seasons. Planting season gave way to tending season, which gave way to harvest season. Now, the movement of the seasons is from one sport to another. Scituate has sent a great number of athletes on to college and professional sports and has been home to others who nurtured a competitive spirit and a sense of fair play in the children of the town. From season to season, there was and is a Scituate athlete battling it out somewhere.

Jimmy Patsos competes at the elite level of the NCAA. College basketball is the game. Tom Cuddihy's passion for hoops saw him become the leading scorer in the state one year. Al Kazlousky loves the way the sport can help young people grow. His story speaks to the best of Scituate.

Bruce Laird and Larry Eisenhauer were Scituate residents who took their skills to the National Football League. Tested against the best, they more than measured up.

Jim Lonborg played on the biggest stage of them all when he led the Red Sox to the World Series in 1967. He chose Scituate in his retirement and the town has delighted in the company of his family.

David Silk and Mike Breen were hockey players. One was part of the biggest surprise team in the game's history; the other was a dynamic high school star who came home to contribute to his hometown as a coach and a public servant.

Everett Dorr's story is a triumph against injury and odds. He was a trailblazer in his desire to offer young women a chance to realize the rewards of competition.

The ultimate female competitor, Mary Bauer set an unmatched standard for coaching success. From her days as a Boston University student to her coaching days, her opponents knew no one would be better prepared to play.

Bill Smith coached and taught the young people of Scituate and made dreams come true. He was also among the nicest men who ever lived. One can battle and not become hard. It was an amazing lesson.

Game on.

David Silk

In an event magnified by Cold War tensions, the US Olympic hockey team defeated a team from the Soviet Union in the 1980 winter games at Lake Placid, New York. On that team, contributing to the grit and hustle of New England small-town hockey, was Scituate's David Silk.

Silk was an instant hit when he left Thayer Academy for Boston University in 1976, earning New England Rookie of the Year honors in 1976–1977. With Silk on the boards, the Terriers won a national championship in 1978. He would join BU teammates Jack O'Callahan, Jim Craig, and Mike Euruzione on the 1980 Olympic team with Euruzione scoring the winning goal over the Russians in the 4-3 classic.

Dave Silk was drafted by the Detroit Red Wings after the Olympics and would play with Detroit in the National Hockey League for three years before realizing a childhood ambition and joining the Boston Bruins. When his playing days were over, he went back behind the boards as an assistant at Boston University. On occasion, Dave Silk still laces up the skates (for charity mostly) and shares a night with old teammates. The Miracle on Ice forward is still bringing his best. (*Scituate Mariner.*)

Al Kazlousky

There is not a young person in Scituate whose face does not light up at the mention of Al Kazlousky. He has meant the world to them because there has been no more steady presence in Scituate youth sports over the past 20 years. The recipient of a rare honor, Al has had the basketball courts at Scituate High School named for him while he is around to know it. He accepted the honor with the grace that follows in his wake.

Al became a fixture on the youth basketball scene when his son Adam signed up. His legend grew when he took on the duty of referee and organizer of the Saturday morning leagues at the Gates Middle School. Famous for his calls and his no calls, Al brought a perspective that this was not just a chance to play, but also a chance to learn. The lessons included basketball, of course, but also sportsmanship, perseverance, teamwork, and character. High school coaches like Roger Kwam, John Eckstrom, and Mat Poirier began to send their teams down to help out on Saturdays. The mix of the high school kids with their aspiring elementary school counterparts connected neighborhoods and peer groups. Who knows how much trouble was set aside when these kids played full court?

Al is also an avid antique car lover. A genius at trivia, he runs a trivia night at the Inn at Scituate Harbor. He has kept a pig as a pet and lives in a fantastic Thomas Lawson legacy home. Eclectic from the tip of his fantastic mustache to his proudly Lithuanian toes, Al knows fun and integrity are not enemies. Mat Poirier said it best on the occasion of the court dedication, "He is a hero. He wants nothing. Asks for nothing. He simply serves the community and loves doing just that. Big Al is the man." (Bob Gallagher.)

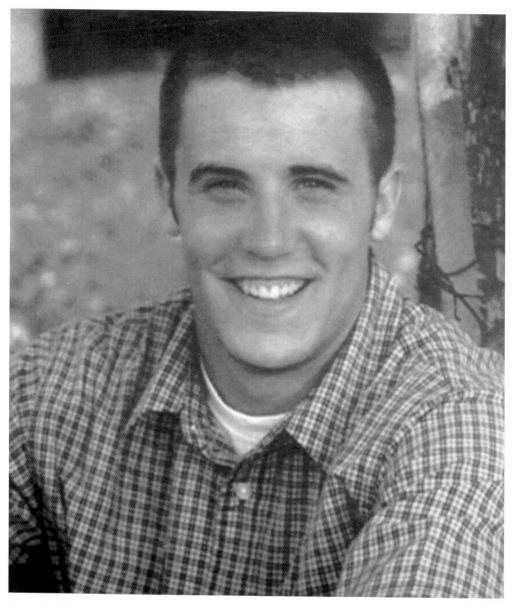

Tom Cuddihy

The leading scorer in the history of Scituate High School basketball, Tom Cuddihy went on to a fine career at Bridgewater State College. He was not the fastest guy on the floor, nor was he the tallest. What he did have going for him was a superb knowledge of the game and a floor sense that put him in passing lanes, got him that half inch to get a jump shot off, and let him move his teammates around like chess pieces. He also took every opponent as a personal challenge, particularly in his senior year when the secret was out that he could score the ball.

Part of an exceptional family of athletes (both of his sisters were college athletes at Bridgewater State), Tom Cuddihy could flat-out score and always gave his team a great chance at a win. (The Cuddihy family.)

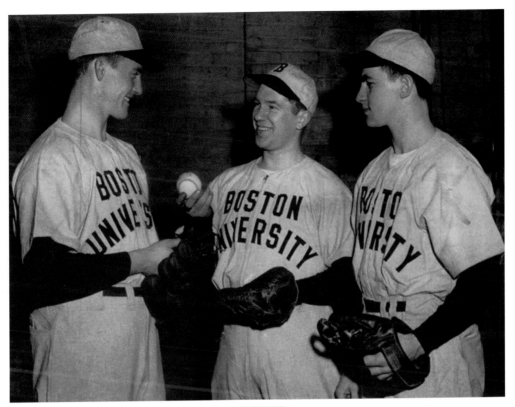

Everett "Evie" Dorr

Everett "Evie" Dorr (above, at left) was a role model for generations of local school children. He served as physical education and athletic director at Cohasset High School from 1949 until 1982. In 1991, the Cohasset gymnasium was named in his honor. The kids across the years loved him because "He treated every kid like a star." Long before Title IX became law, he advocated giving as much attention and practice time to girls' sports as he did to the boys.

Evie was a standout athlete at Boston University and is a member of the BU Hall of Fame. Leaving school, Evie became a Marine paratrooper. At Iwo Jima, he sustained shrapnel wounds that left him with permanent nerve damage. Undaunted, he returned to BU after the war, becoming the placekicker and setting a scoring record that stood for 23 years. (The Dorr family.)

91

Mary Bauer

The Boston University Hall of Fame is home to another Scituate legend, Mary Bauer. Known as the coach of many undefeated tennis teams and for other athletic achievements at Scituate High School, Mary taught with a firm hand and a winning spirit. As a longtime coach, Mary was especially good at spotting talented players and bringing out their best efforts.

Her Boston University citation notes that she competed in eight sports in her career there. It also notes her achieving the unusual distinction known as "Tuegras," a term that indicates reaching the pinnacle of accomplishment. She would do the same thing at Scituate High School where her tennis teams won an astounding 326 out of 332 matches. While tennis was clearly a perfect fit for her, she also coached field hockey and basketball for a combined 59 years. (Scituate Historical Society.)

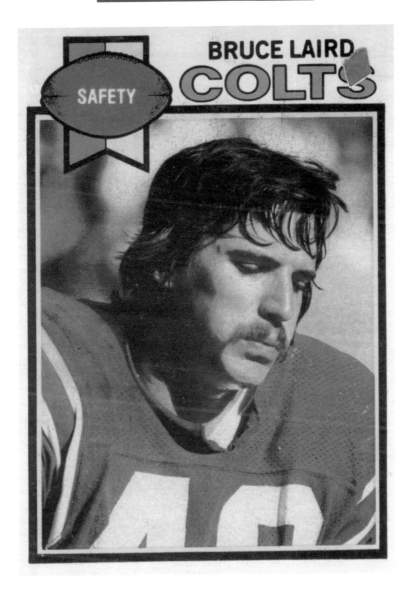

Bruce Laird

Three rookies were chosen as National Football League Pro Bowlers in 1972. Scituate High School's own Bruce Laird was one of them. Making his mark as a kick returner for the Baltimore Colts, Laird gained more than 1,100 yards in the 12-game season with a long return of 73 yards to his credit.

Not long removed from the Old Colony League and American International University, Laird had been drafted by the Colts and would later play for the San Diego Chargers and the Arizona teams in the United States Football League. His post playing career has been marked by contributions to improving the safety of the game. Bruce Laird is the founder of "Fourth and Goal," an organization seeking to address the health concerns of retired players.

Laird currently serves the Baltimore Ravens as their uniform inspector. The former player has the pregame job of checking for violations he was once known for—the note on the helmet or the cut off sleeve. He is judicious though. In one instance, when he noticed a Raven quarterback in violation by wearing the high top shoes of Baltimore legend John Unitas, Laird told the league official, "I will stay right here and laugh . . . while they are decapitating you." (Vintage Football Card Gallery.)

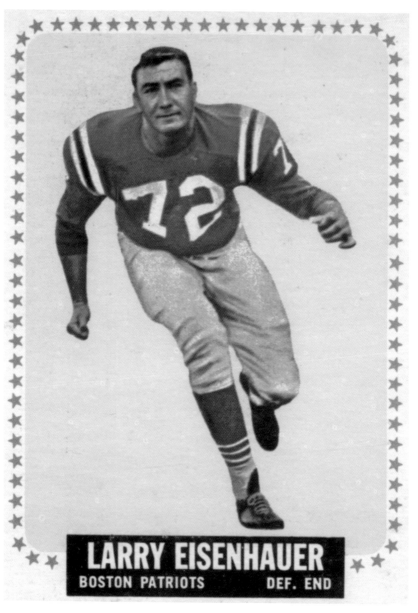

LARRY EISENHAUER
BOSTON PATRIOTS DEF. END

Larry Eisenhauer

Drafted in the sixth round (42nd overall) by the then Boston Patriots, Larry Eisenhauer would play himself into the American Football League Hall of Fame and the Patriots All-1960s AFL Team. A relentless competitor, Eisenhauer was called "Wild Man" by his teammates. Clad only in an athletic supporter and his helmet, he once took to a snowy Kansas City field to rev himself up for the day's game.

Eisenhauer was born in New York but came to New England to play defensive end at Boston College. After a sensational career at the Heights, he settled in Scituate where he participated in charitable and civic work during his playing days and after. In the summer of 2012, Eisenhauer helped celebrate the Fourth of July by offering a reading of the Declaration of Independence during the festivities. The Wild Man of the AFL has been a great neighbor, and Scituate has been a great fit for the one-time gridiron legend. (Vintage Football Card Gallery.)

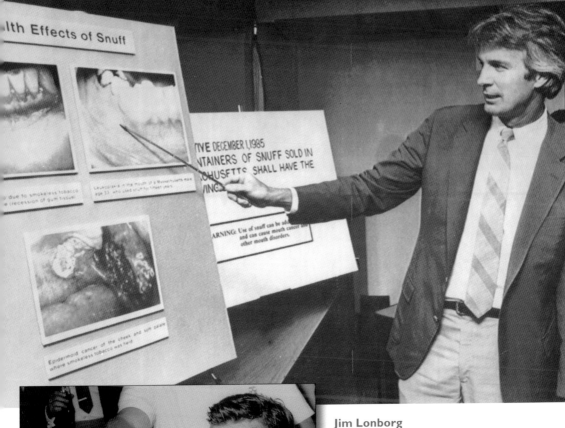

Jim Lonborg

In 1967, there was one arm that carried the load. There was one guy wearing No. 16 who dazzled. No one alive and aware in 1967 will forget the bunt and the mob scene on the mound or the effort on short rest.

Jim Lonborg moved to Scituate after his playing days with the Boston Red Sox and the Philadelphia Phillies. Establishing a dental practice, he also contributed to the formation of the Scituate Little League in the late 1970s. He and his wife, Rosemary, are prominent faces for the Jimmy Fund, and Rosemary's story about her husband, *The Quiet Hero*, is a perennial best seller in children's books. (Scituate Historical Society.)

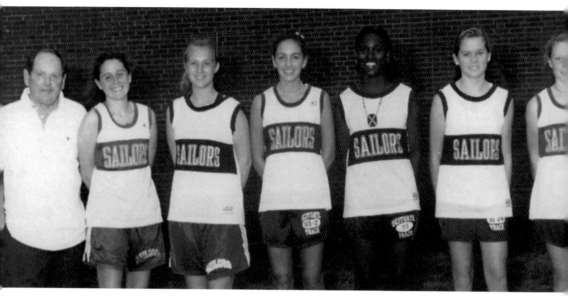

Bill Smith

Bill Smith coached them all—from the young kids who were introduced to games in an elementary school gym to the Olympic athletes at Boston University. With an unmatched patience, a humble drive to win and then win again, and a storied eye for talent, Coach Smith sent three generations of Scituate athletes to the legendary track programs all around the country.

Coach to David Hemery—who attended Boston University and won the gold medal in the 400-meter hurdles in the 1968 Olympic games and two more medals in the 1972 Olympic games—Bill Smith did double duty as the physical education teacher at Scituate's exploding elementary schools. These young people would be the beneficiaries of his attention later on when, as high school athletes, he was able to groom them to go onto the programs at Boston University and Nebraska, to just name a pair.

An accomplished track athlete in his own career, Bill Smith held many records at Boston University and was twice named to the US National Track Team. (Scituate Historical Society.)

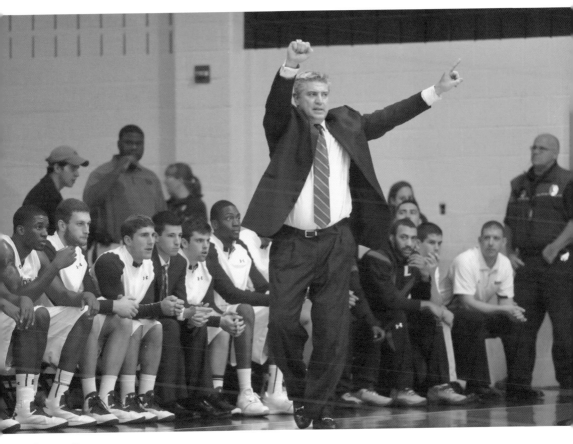

Jimmy Patsos

The story is a familiar one: a small-town kid with big-time hoop dreams. He leaves town, gets involved with one of the biggest names in all of college sports, works his behind off, and finds himself on the big stage.

Jimmy's career began at Maryland with longtime coach Gary Williams. Coaching such stars as 1995 College Player of the Year and No. 1 overall pick Joe Smith was a trial-by-fire for the then 27 year old. With his salary restricted by an NCAA rule concerning coach's pay, Jimmy tended bar after his day job was done, hearing once from Marquette college legend Al Maguire that it was the perfect training ground to learn how to deal with people.

Moving from Maryland, Coach Patsos took over at Loyola Maryland. Starting off with a team that got its brains kicked in routinely, in 2012, Patsos led his squad to the NCAA mens' tournament. In 2013, Jimmy moved onto Sienna. With a flair for the theatrical (his dad Charlie won a Tony as a producer on Broadway and his sister Terry has her own syndicated television show), Jimmy has brought a program from the sticks to the big time. (Loyola University.)

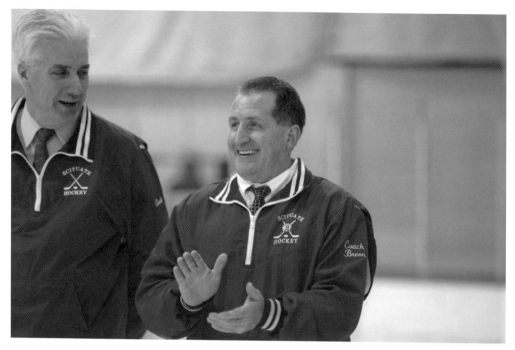

Mike Breen

When hockey was king in New England, Mike Breen (pictured above at right, with Kevin Duggan) was the Scituate star. Strong, tough, smart, and a playmaker, Mike carried the Scituate High School team to the Boston Garden in 1975. Later playing at the junior hockey level and in the American Hockey League, Mike tried his hand at another sport when he spent some time working with the World Wide Wrestling Federation. The coach of the Scituate High School hockey team for many years, Mike is also the director of the Scituate Highway Department, following in the public service footsteps of his father who served as Scituate's fire chief for many years. (Bob Gallagher/Scituate Hockey Boosters.)

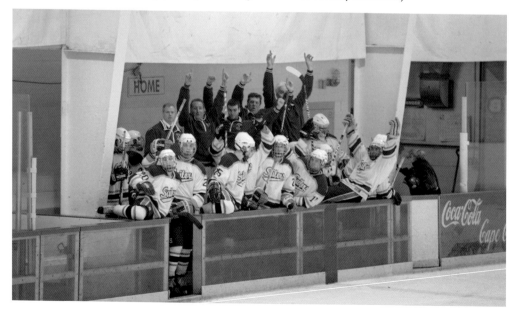

CHAPTER EIGHT

Notable Women

There can only be understatement. Words will fail. The myriad ways that women in Scituate have contributed to the growth and the health of the town can only be tallied to an approximation. It started before Rebecca and Abigail Bates saved the town during the War of 1812. While the majority of the choices in this book are men, those men would acknowledge the role the women in their lives played in their advance. Consider this a small sample, then, of the better half in Scituate.

Dr. Ruth Bailey brought babies into the world and might be there when those babies brought their own into the world. No one can explain where her drive, her relentlessness came from.

Pam Martell shapes the spaces residents share with each other. She is a teacher in the guise of a designer.

The tale of Lisa Berg is an inspiration. Truly self-made and the very definition of hard working, Lisa built a family, saved a family, and helped the families of Scituate all through her life.

Millie Whorf would play. The crowds would gather to sing and dance and leave the tough days of depression, war, and struggle behind. There was a cure in her piano that was the antidote to a host of problems.

Jean Hoogeveen and Joan Powers give and give and give some more. Extraordinarily selfless, their example is one of carving out a place by making a place better.

Betty Foster has found countless ways to save the past for the future. She is one part scholar, one part professor, always eager to discover another secret and to share it.

Ceil Coan pushed through a glass ceiling at Scituate Town Hall. When she did, she became a guiding star there.

Esther Prouty worked the land and spoke her mind. When she took a stand, there was no backing down. The students she influenced are impossible to count.

Margaret Miles was a devoted wife and mother and when war came, she became more. Her story takes her from the jungle of Asia to a jail cell in America.

Take note.

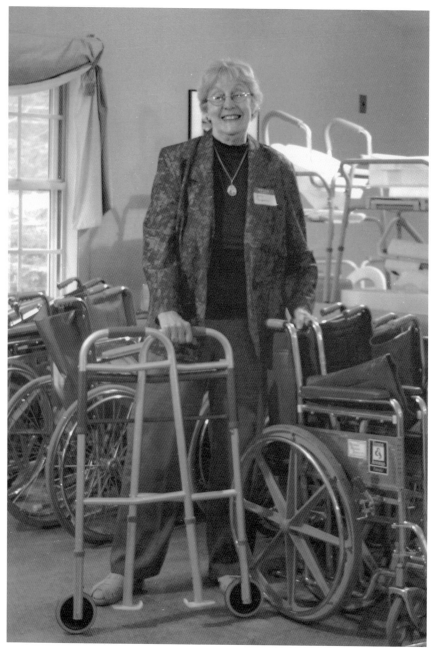

Jean Hoogeveen at Etrusco Associates

Got a bum leg? Go see Jean. Had an operation? Go see Jean. Not sure what you need? Go see Jean. Can't make it over to the Etrusco Associates? Jean will come to you.

Caregiver extraordinaire Jean Hoogeveen has seen to it that the vulnerable, the walking wounded, and the recovering of Scituate have received the best possible care. First as the director of Elder Services and then as the chair of the Etrusco Associates, Jean has sought to quietly guide both agencies to those in need. With little fanfare, she has made a tremendous difference in the lives of Scituate residents. (Linda Martin.)

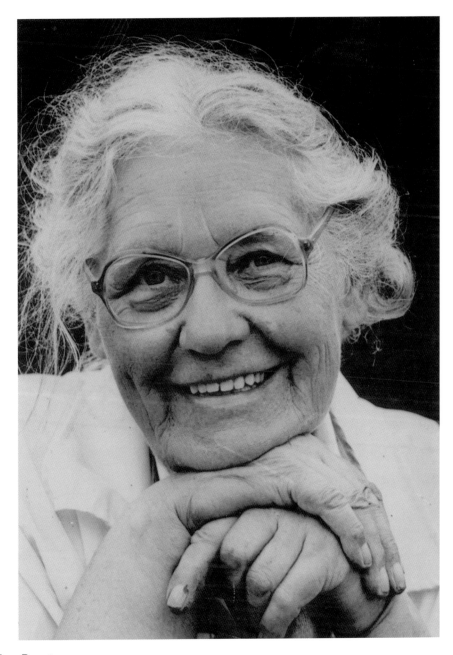

Esther Prouty

There was no missing Prouty's Farm Stand on First Parish Road. It had been there since 1931 when Esther and her husband, Wilfred Prouty, began selling vegetables, fruit, and flowers in order to make a living during the Great Depression.

Esther came to Scituate from Belmont with her family and graduated from Scituate High School. It is said that she met her future husband while he was skinning a skunk—she married him anyway. Taking care of the farm and selling produce in the summer, Esther was employed in the high school during the school year. In later years, she was a hall monitor at the high school, making sure there was no smoking in the girls' room! (Jean Curtis.)

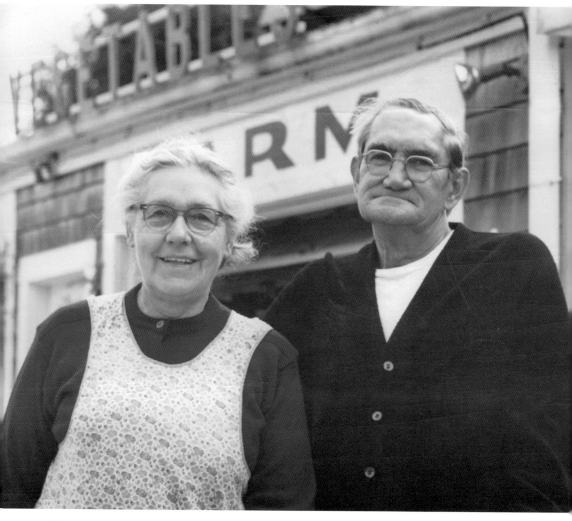

True Character
In 2005, a painting of Esther Prouty hung in the White House as part of the Christmas celebration. It was painted by famous local artist Donna Green as an illustration in Green's book, *We Wish You a Merry Christmas*. Esther had the kind of character that was unforgettable, and it showed. She was hard working, kind, independent, honest, and blunt, and her no-nonsense language made sure she got and kept attention. (Jean Curtis.)

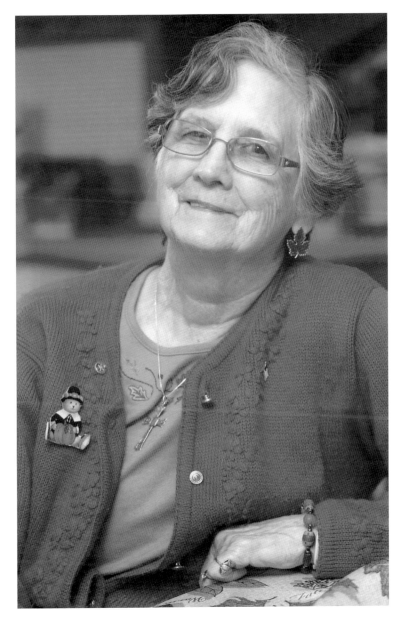

Joan Powers

Since arriving in Scituate in 1989, Joan Powers has been going nonstop. Volunteering has been her passion, and every group that has been touched by her gifts has been improved tenfold. From Meals on Wheels to the Council on Aging, at St. Luke's Church and at the Scituate Town Library, with the Scituate Rotary Club, and with the South Shore Elderly Services, Joan has been tireless in her efforts to fulfill a vow she took more than 50 years ago. The Third Order of Saint Francis vow calls for a commitment to those less fortunate. Scituate has seen that determination realized in the day-to-day efforts of this amazing woman. Whether as a caregiver to her beloved husband, Rev. Fred Powers, who suffered head trauma shortly after moving to Scituate, or before that, as his wife during his service as a prison chaplain, Joan Powers has found and made opportunities to enrich the world with her patience and compassion. (Chris Bernstein/*Scituate Mariner.*)

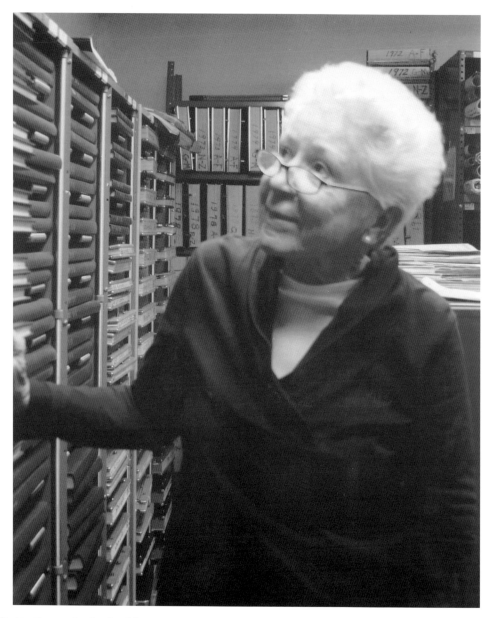

Betty Foster in the Archives

What hasn't she done to preserve Scituate's history? At one point, she served as the lightkeeper. For many years, she was the secretary to the historical society. Betty has been the archivist at the town library. She has authored articles on local sites. She has contributed to the must-have books on World War II and the Civil War. Betty's work will speak for itself when she finally decides to call it a day.

A long-time nurse at South Shore Hospital, Betty took over the lightkeeper's job in the early 1970s. When family called her back across the harbor to Front Street, she went but found other outlets for her love of the area at town hall and the library. An inspiration to so many for her common sense and her generosity, Betty has helped countless families in genealogical searches and countless businesses in tracking down the records needed to resolve legal issues. Need an answer on Scituate history? Betty Foster is the best place to start. (Julie Gallagher.)

Ceil Coan

First assistant town administrator Ceil Coan was a fixture in town government for more than 23 years. She started as secretary to Scituate's waterways commission and began recording minutes for Scituate's board of selectmen. In 1974, Scituate's first town administrator, Edward McCann, asked Coan to be his secretary.

Subsequently, she worked for the next four administrators: Edward Donnelly, Dick Bennett, Herb Gilsdorf, and Keith Bergstrom. Having become knowledgeable enough in the duties of the town's chief executive, the selectmen appointed her acting town administrator in October 1989, upon Bergstom's resignation. She held that post until the appointment of Richard Agnew in March 1990. He valued her expertise so much that he appointed her to be his administrative assistant and then assistant town administrator.

Because of her talent and dedication, Coan was named Citizen of the Year in 1994 and received accolades from state and local dignitaries, even receiving a note from President Clinton. She accepted the award on behalf of the many municipal and school employees who toil behind the scenes, ending with, "I thank you from the bottom of my little Polish heart."

Coan loved her job and was always cheerful, charming, and knowledgeable, making people with whom she was in contact leave with a feeling that they had been heard and had a good explanation of what would happen next. Selectman chairman Joe Norton described Coan as "an oasis in a desert of turmoil." (Scituate Historical Society.)

Dr. Ruth Bailey

The first woman physician in Scituate was affectionately known as "Dr. Ruth" (pictured at far right). Her wavy red hair, no-nonsense attitude, wry sense of humor, and motherliness made her beloved by patients and friends alike.

Dr. Ruth began her practice in 1941, and beginning in 1962, her office was in the Bailey Building on Front Street. Her specialty was as an osteopath, treating diseases by manipulating bones and muscles. She also delivered babies. There were whole neighborhoods made up of people who were welcomed into the world by Ruth Bailey. If one woke up with a sore back, she was the first call. Maintaining the long lost practice of house calls—often in the middle of the night—made her especially sought after. Those who could not afford her services were often treated for free.

Dr. Bailey served for 35 years on the staff of the Massachusetts Osteopathic Hospital and Medical Center in Boston. Upon her retirement, the hospital established a patient assistance fund in her name. William Trifone, a hospital trustee, said of her, "She set a standard of patient care that will be hard to match," and continued, "Other people talk about holistic medicine. She lived it. She's just a great person."

In 1977, Dr. Ruth Bailey was honored as Scituate's Citizen of the Year by the Scituate Chamber of Commerce. Married to Robert F. Gammon, the couple made their home at Dr. Ruth's childhood home on Third Cliff. The bigger truth is that all of Scituate was a home to her. She knew the ins and outs of every neighborhood, and countless families were soothed by her care. (Scituate Historical Society.)

Lisa Berg

Lisa Berg (above, at left) emigrated, with the help of her father, from Sweden to the United States at a young age and learned English while working many menial jobs. When her family went back to sea with the Merchant Marines, she found herself alone in a strange land.

A job as a domestic brought her to Scituate, and bad luck became good luck when she met the Appletons. For more than 20 years, she worked at their dairy farm. Establishing herself, she adopted her nephew Paul as her own. When circumstances displaced the Appletons, she took them in too. A painter, builder, tour guide, and bus driver for the town, Lisa Berg was loved for her energy and faith. Her proudest moment may have been seeing Paul graduate from the Massachusetts Institute of Technology. Lisa Berg's is an "only in America" story. (Paul Berg.)

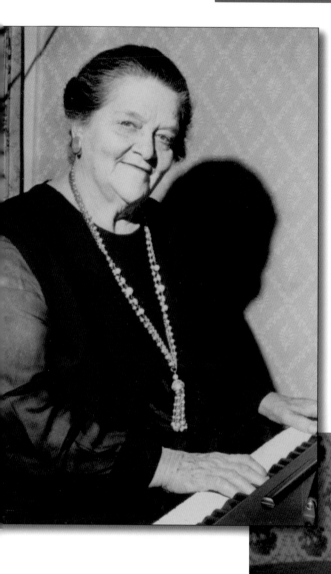

Mildred Whorf

One only had to follow the music to find Millie Whorf. She started as a drummer in her mother's (Fanny Burleigh Merritt) band at the B.F. Keith Vaudeville Theater in Boston after attending the New England Conservatory. She performed locally at the Idle Hour Theater on Front Street, and the Victoria Theater in North Scituate.

If there was a dance, Millie played. If there was a wedding reception, Millie played. The Scituate Proving Grounds during both world wars, dances, weddings, area nursing homes, the Sunlight for the Blind on Branch Street, and veterans' hospitals were the places and events on Millie's agenda where she aimed to bring sunshine, hope, and fun to those who needed it most. (Carol Miles.)

Margaret Miles

College graduate, missionary, school committee member, social worker, poet, and peace advocate—these terms describe the long life of Margaret (Bailey) Miles.

As a newlywed, Margaret accompanied her new husband into the middle of Burma (now Myanmar) to do missionary work, and it was there that their three children were born. Her days on the Scituate School Committee were not without strife during the McCarthy era as she advocated and fought for freedom of expression (such as the school prayer controversy), which branded her as a "Communist."

After her husband, Dr. Max Miles, died, Margaret (now in her 80s) became active in the peace movement, participating in marches and in sit-ins. Her spirited correspondence with US senators, the president, congressmen, and others of political influence spanned many years. She even found a way to get arrested a time or two. (Carol Miles.)

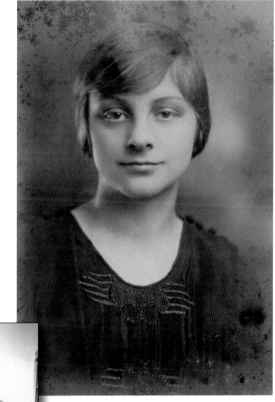

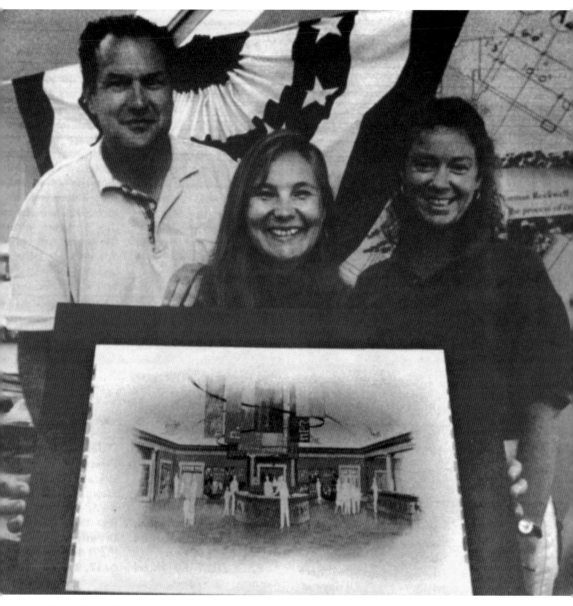

Pam Martell

Some people just have "it." The "it" is usually undefinable, but it is recognized and deferred to gladly. Pam Martell (center) has "it." Call it talent, or an eye for detail, or a vision for how people will interact with space—either way, there is something special about Martell's interior designs. They work. People want to come back, and they can't say just why. It just feels right.

Most famous for her work designing the Norman Rockwell Museum in Springfield, Massachusetts, Pam has donated to Scituate with her attention to the Maritime and Mossing Museum, the Grand Army of the Republic Hall, and the Kathleen Laidlaw Center (also known as the Little Red Schoolhouse). In each of these places, people can find "it." Pam Martell put it there. (Scituate Historical Society.)

CHAPTER NINE

The Unforgettable

There is a kind of person in Scituate who contributes to the quality of life in a way that begs to be described. Part sage, part shaman, part kook, part always to be relied upon, Scituate has been home over time to many decent and fun-loving and off-the-wall characters. There have been individuals who were self-serving and those who were self-effacing. The mix is hard to fathom.

Percy Mann offers tale after tale of a man who could not and would not fit in. He was the ultimate iconoclast who turned his back on modernity. John Brown made his peace with the changes and did not let the world spook him. He just kept walking on.

Teak Sherman and Carl Chessia were contemporaries who brought humor, devotion, and everyday common sense to Scituate. Small-town life needed the calm they brought. Their curiosity saved a lot from being lost too.

Dominic Bonomi's story is hopelessly sad. It is an example of a dark side of society that was only emerging as he made his choices.

A counterpoint to the despair of the Bonomi story is that of Bob Magner, whose devotion to the sick and healing has set an example to displace any cynic's stand.

Rudolph Mitchell took the pictures that tell the stories. He had the eye that could see that the everyday life of a small town was immensely valuable.

Paul McCarthy was a legend in his field. The homes of Scituate are adorned with his creations.

Anchoring a neighborhood is no easy task. Somehow, despite a disability, Itchy Cohen did it.

Alfred Gomes was a farmer. He also was a man of faith whose donation of land to a church prompted a time of reflection for some and anger for others.

In North Scituate, Ward Swift made a life that included the Baptist Church, the Boy Scouts, and a mysteriously built glider. Merrill Merritt came back from World War II and contributed his skills to building housing.

Bill Sexton drew. He told stories. People laughed and wanted him around. He was a blast; he was one of a kind.

Fran Litchfield belonged to one of the oldest families in town. He carried forward their service and improved upon it in the varied roles he took on. He might be the embodiment of the town in his combination of foresight and reverence for history.

It would be hard to forget them.

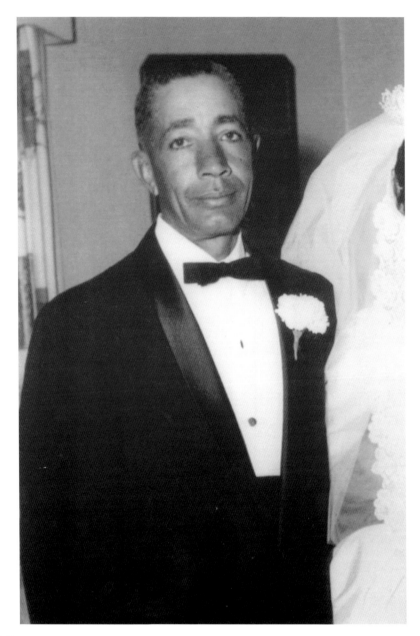

Alfred Gomes
The feeling would come over you on a summertime afternoon: you had to have some corn on the cob for dinner. Your favorite aunt loved squash and you wanted to make her smile. Your mother had burst the budget and bought you Cool Whip. You needed the strawberries to go with it. When that feeling came, you headed down to see Alfred Gomes at the Pitcock Farm on Kent Street. He had everything.

In his later years, Gomes fed into some controversy when he donated his land to the Roman Catholic church for the purpose of building housing for low- and moderate-income families. This type of housing was a departure for Scituate. The magnificence of the gesture got lost in the perceived revolution of the outcome. Gomes was doing the right thing as he saw it. He was acting on conscience. It took resolve to hold fast and be the man that Alfred Gomes was. (Connie Gomes.)

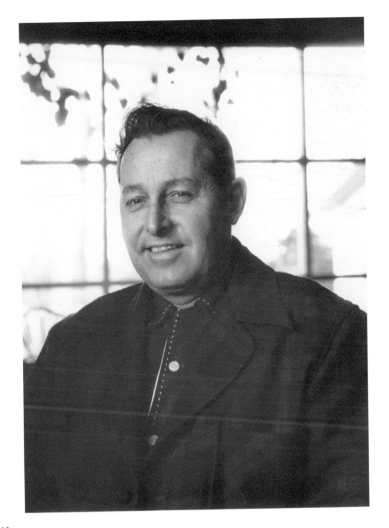

Ward Swift

Shortly after Ward Swift and Marjorie Newcomb were married, they built a small house on a lot in back of the Baptist church. There, Ward found an outlet for his abundant energy by building a glider in the attic of the house. Upon completion, and much to his consternation, he discovered that he had to tear open the end of the house in order to get it out!

The glider parts were assembled on the wide beach at Humarock and a mostly successful flight was made, with Ward a novice at flying. Not to be outdone, and after repairs, another try at flight was made at North Scituate Beach. Then there were more repairs. This loud activity took place during church services, which was strictly frowned upon.

In his real job, Ward was an insurance agent representing Holyoke Mutual and National Life Insurance Company from 1938 to 1987. Ward knew everyone in town and was named the Citizen of the Year in 1987. Active in the Scituate Scouting program, he helped guide many boys in activities such as building a cabin on Scout property off Summer Street and seeing that the mill pond dam there was well built. Under his tutelage, the Scouts enjoyed the Mill Pond retreat for many years as well as trips to the White Mountains for hiking, camping, and trailblazing. One rumor has it that the Scouts dug Ward a pool too.

Ward loved anything mechanical and kept a meticulous and well-stocked shop. Anyone was welcome to borrow a tool, but it had to be recorded on a sign-out sheet, and woe to those who forgot to return a tool! (Scituate Historical Society.)

Carl Chessia

When seeking a single person who was part of nearly every aspect of town life in Scituate, Carl Chessia (above, center) comes to mind first. A Thomas Lawson aficionado, Carl and his wife, Jane, saved more of the Dreamwold estate than the old Copper King Lawson himself. A tree warden, mosser, and lobsterman who landed a shark while looking for bait, Carl worked for the town in a million ways. He was always in the middle of things, at Pickles Young's alleys, on the beach, in a dory, and later at town hall. Sharing a wealth of stories every day with whatever company he was keeping, he was always great fun to be around. (Bob Chessia.)

William Tecumseh "Teak" Sherman
Though there are water commissioners in every town, it is probably safe to say that no town ever had a water commissioner like Teak Sherman.

Be it fishing Charlie Bailey's teeth out of a cesspool (only to see Charlie plunk them back in his mouth after a run under a hose) or forgetting to turn off the pumping station and having Mrs. Sylvester get a surprise as she visited her water closet, Teak—"Willy" to his friends—was in the middle of a thousand goofy stories. Sometimes a poet and a carver of unique wooden animals, Teak had a curiosity about life and a passion for the town of Scituate. Lawson Tower was in Teak's domain as water commissioner, and he saw to it that no harm came to the beautiful water tower. (Scituate Historical Society/Bob Chessia.)

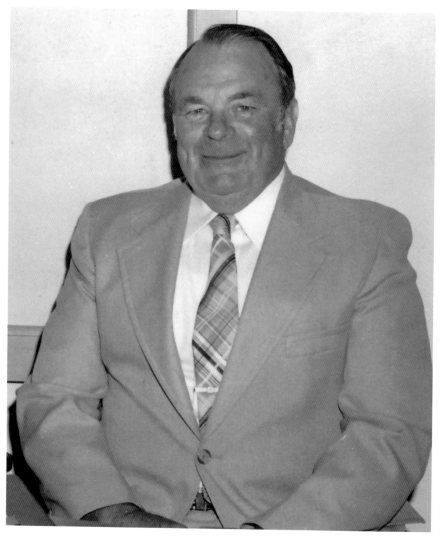

Merrill Merritt

Imagine being in a line and hearing an infectious laugh. Imagine a group gathered round, first with a snicker, then a giggle, then a hoot. Chances are Merrill Merritt was in the center of that group. Merritt was special in that he loved people and loved to tell stories about Scituate. He always had a smile and a cheerful greeting for those he met.

Merritt grew up in Scituate and dedicated his life to helping others. Someone in need could always find a sympathetic ear with Merrill. He was also known to dip into his own pocket to lend a helping hand. Without any fanfare or publicity, Merrill saw people through a challenge.

A World War II veteran, he served in the 832nd Engineers and Aviation Engineering Battalion as a construction machine operator. He saw action in many areas of Europe, including at the Battle of the Bulge. His stories of being on a troop ship both going to and coming back from Europe were always told in a humorous way; he somehow managed to leave out the fact that convoys were being torpedoed every day.

Upon his discharge in 1945, Merritt started his own successful plumbing business in Scituate. In 1959, he became the director of the Scituate Housing Authority, serving in that capacity for 36 years. When the Central School was converted to public housing, Merritt served as clerk of the works. (Chris Merritt.)

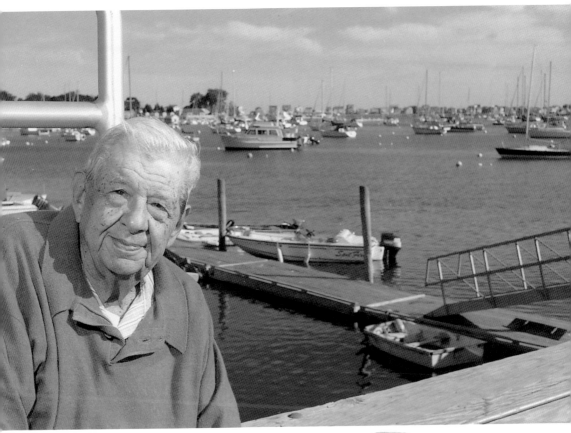

Rudolph Mitchell

No one knew the faces of Scituate like Rudy Mitchell.

A master photographer, Mitchell's work has appeared in outlets all over the South Shore. He was the school photographer as well, which meant that many a grandmother had their grandchild's Rudy Mitchell masterpiece on the fridge. His work stands with the finest documentary work on a small town.

In his semi-retirement, Rudy took on the task of raising and lowering the flag on the Scituate Town Pier. He was quoted saying he felt "it is important for people to realize how much the town does for the community—the things that they do to keep the town up and going and to improve it." Well said by a true gentleman. (Robin Chan/*Scituate Mariner*.)

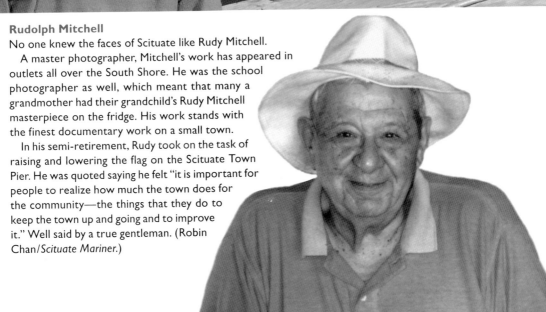

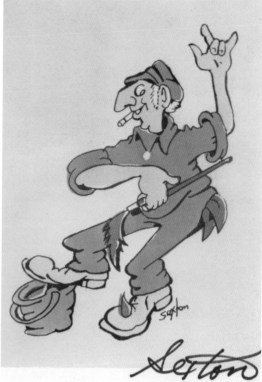

Bill Sexton

There are some people who beg to be described in the most florid of language because they bring to life a spirit and a joy and an irreverence that is unbridled. Bill Sexton was that kind of person. With a fabulous talent for caricature, for storytelling, for bending the elbow and bending one's ear, Bill worked for the town of Scituate after serving in the Navy during World War II. Painting signs and curbs and tending to the details of a developing suburb were what he got paid for; what he did was draw and entertain and all he needed was, as his one-time coworker Mat Brown recalled, someone to say, "and then what happened?"

Bill was offered a job with Walt Disney studios in the late 1940s. He turned it down to stay in Scituate. In the late 1970s and 1980s, he caught on with the *Scituate Mariner*, running a weekly cartoon that is as fine a commentary on the local scene as anything Scituate's more famous political cartoonist, Paul Szep, created for the *Boston Globe*. Bill did not win a Pulitzer Prize, but no one who ever shared a minute with him would forget his vigor, humor, and often profane insight into a local controversy or about an elected official who had forgotten his or her roots.

Mostly, his friends remember his wit and his generosity. A hand-drawn card would arrive a day after he sat at dinner with his dear friends the Chessias. A Sexton caricature upon a retirement was far better than a gold watch. He was fun and full of the devil. Bill Sexton: Scituate's own genius of ink and chalk. (Scituate Historical Society/Bob Chessia.)

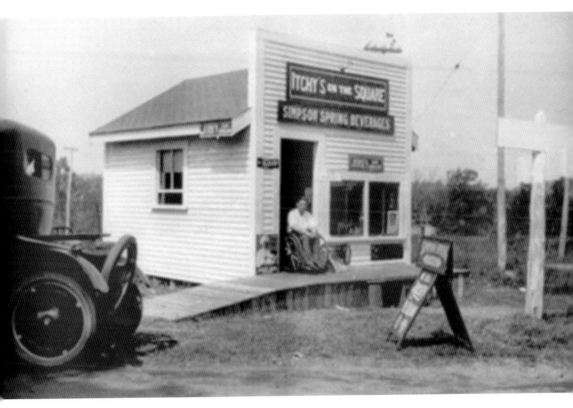

Israel Cohen
Injured in an accident that rendered him paralyzed, Israel "Itchy" Cohen was a handsome and charming man who ran a small store on what is now "Itchy's corner." He sold milk, eggs, tonic, and other don't-want-to-run-out-of items. He also had an interest in a numbers game. Bets could be made down to one cent. Itchy had a car that was modified so he could operate it, and a wheelchair-like runaround built by his neighbor Ray Litchfield. An uncle to Lester and Chick Gates, Itchy knew how to have a good time, how to make a buck, and how to persevere through a challenge. Folks in town think about him still when they drive by the pole in the road across from his former store that has come to have his name. (Scituate Historical Society.)

Percy Mann's Car

As the saying goes, they broke the mold when Percy Mann was born. Son of a long-settled Scituate family, Percy met the 20th century on his own terms. From the family home on the corner of Greenfield Lane, he met the changes and challenges of new technology with reluctance and outright resistance.

Once upon a time, Percy bought himself a motorcar. When informed that said motor required a registration and a plate to be safely on the road, he roared his rejection to any ear that would hear it. Unable to conquer the bureaucrats of his day, he retreated to the family home, parked the car, and left it to the elements. Well, not so much the elements as a single tree that grew right up through the middle of it.

Much of his life was spent in complaint and rectitude. One complaint was that the town had stolen property from him. An example of rectitude was his refusal to sleep in the same house as his unmarried sister. He slept on the porch instead. It was once said of Percy Mann that he would jump into a thorn bush in order to not have to say hello.

Percy discovered a pirate's treasure at the base of Third Cliff, and when he died, his heirs said the town could keep his land, his house, and furniture if they could keep what was left of the treasure. It must have been some treasure.

He owned some land that was next to the town's gravel pit near Gilson Road where the town would dig up sand and gravel. When the town went over the line and dug sand and gravel out of Percy's land, he was outraged and decided to sue. He won and was presented with a check. Uncashed, that check was found on the mantle when he passed. Like they say, they broke the mold. (Scituate Historical Society.)

John Brown

Noted local historian David Corbin captured the unique qualities of John Brown this way: "Uncle John Brown was born in Scituate in 1808. He began his trade as a ship caulker at several of the shipyards on the North River. He later married & had four sons. Two of the four Frank & George were killed in action during the Civil War. Later, as the North River shipyards began to close, Uncle John found employment in the shipyards of East Boston. He walked from Scituate to his new employer each day. As he aged he continued to walk to East Boston but found lodging in the city and walked home for the weekend. On Sunday he and his wife Clarissa walked from their home on Pincin Hill to the then recently built North Scituate Baptist Church, a short walk! (It is roughly four miles) Until the age of 95 Uncle John led each town parade. Folks marveled at his stamina and noticed the younger participants struggling to keep up with him. He passed away quietly in his sleep at the age of 97 in 1905. At the time he was the oldest resident in Scituate." (Scituate Historical Society.)

Dominic Bonomi

One of the saddest chapters in Scituate's story was that of Dominic Bonomi, who introduced the town to the reality of domestic violence when he was arrested and convicted for the murder of his wife in 1955.

It was a case full of garish details. Mildred Bonomi had been dumped in a gravel pit. The body was discovered after heavy rains washed down the gravel. The defendant carried himself like a movie hoodlum, specifically George Raft, the king of the B-picture gangsters. His grinning and cheerleading from the defendants' box did not help him, though, as he was sentenced to life in prison. He later asked for a lie detector test and failed it.

Bonomi served 23 years before being released on parole. He lived 16 more before his passing. (Scituate Historical Society.)

Bob Magner

Beginning in his junior year in high school, when he first visited the Sunlight House on Branch Street to help children with special needs, to the present day as a weekly volunteer at Children's Hospital, Bob Magner has lived a life as noteworthy as anyone who ever lived in Scituate. Once serving as a Peace Corps volunteer in Gambia, his life has been marked by making a difference in the lives of the poor, sick, and weary. There have been other perks outside the smiles and the hugs—Bob once got a chance to walk the red carpet with supermodel Adriana Lima at the ESPY Awards. Recognized by the Boston Red Sox and the Boston Celtics in their "Heroes Among Us" campaign, Bob was awarded the Bob Grogen Distinguished Service Award by Children's Hospital for his tireless efforts. (Scituate Historical Society.)

Paul McCarthy

The work of Paul McCarthy hangs in countless homes and businesses in Scituate and beyond. A master woodworker, McCarthy kept a shop in Scituate Harbor for many years where the smell of new wood and shavings welcomed any visitor. Quarter boards with all the names of the Scituate families, new and old, were carved there. Beautiful eagles and ducks and other creations emerged from his commissions and his imagination. He was so highly regarded that for a time he was the in-house woodcarver at the USS Constitution Museum in Charlestown. An author of two books on woodcarving, Paul McCarthy has been a teacher and made his living transforming the plain board into a work of art. (Scituate Historical Society.)

Francis Litchfield
Francis Litchfield could be remembered as a mechanic who helped American flyers make it "Over the Hump" during World War II. He could be remembered for his garage that came to be called "Greenbush Tech" by the kids who hung around. Francis also could be defined by his 64-year marriage to his wife, Nancy. None of these descriptions, though, capture the spirit of the man. He was generous to those he did not know, generous with time and resources. (Steve Litchfield.)

Man of the Community

Francis Litchfield loved the town and the country and saw his children serve as he had served. As his son Douglas told a friend at his passing, "My father was a father to everyone." At home in the field and on the water, "Frannie" was a part of the fabric of Scituate and likely the best of it. (Steve Litchfield.)

INDEX